IMAGES
of America

SAN FRANCISCO

CALIFORNIA

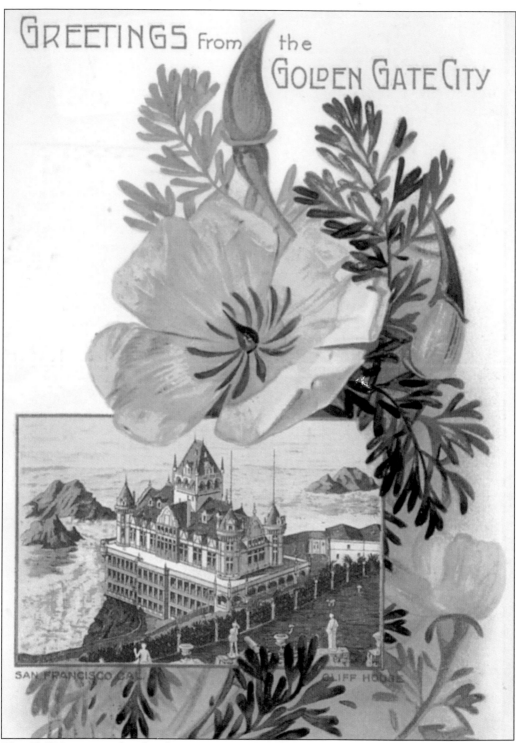

GREETINGS from the GOLDEN GATE CITY

The Cliff House was already a favorite image of San Francisco when it graced this 1907 postcard. This eight-story Victorian beauty with panoramic windows and observation tower burned down that same year and was replaced in 1909 with the present popular restaurant.

IMAGES
of America

SAN FRANCISCO

CALIFORNIA

Patricia Kennedy

ARCADIA
PUBLISHING

Published by Arcadia Publishing
Charleston, South Carolina

Printed in the United States of America

Library of Congress Catalog Card Number: 2001093330

For all general information contact Arcadia Publishing at:
Telephone 843-853-2070
Fax 843-853-0044
E-Mail sales@arcadiapublishing.com
For customer service and orders:
Toll-Free 1-888-313-2665

Visit us on the Internet at www.arcadiapublishing.com

This book is dedicated to my niece, Meghan.

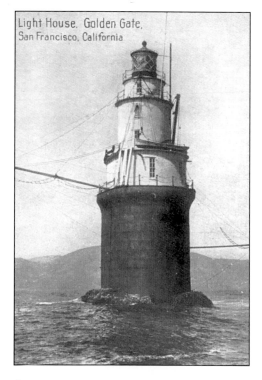

This 1908 postcard shows the recently completed Mile Rock Lighthouse. Construction of the three-tiered lighthouse atop a 39-foot reinforced concrete foundation was an engineering feat. Until a 1950 renovation added a helicopter pad and an automatic signal light, keepers and visitors braved the choppy seas to climb a rope ladder that was the only access to the lighthouse.

CONTENTS

ACKNOWLEDGMENTS

I wish to extend my gratitude to the following people who provided assistance in my search for additional photographs and information for this book:

Pat Akre and the extremely helpful staff at the San Francisco Public Library History Room, Steve Davenport at the National Maritime Museum, Michelle Heston, Kristina Detjen, Mr. Henry L. Detjen Jr., Richard and Brenda Musante, and a special thanks to my editor, Keith Ulrich.

The photographs and postcards shown in this book are from my private collection except for the following:

The following photographs are provided courtesy of
THE SAN FRANCISCO HISTORY CENTER, SAN FRANCISCO PUBLIC LIBRARY:

6, 9, 10B, 11A&B, 13A&B, 14A&B, 16A&B, 17, 18, 20, 21A&B, 22B, 24A&B, 26A, 32A, 33A&B, 34A, 36, 37B, 38A, 41A, 50A, 72B, 74A, 77B, 78A, 80A&B, 86B, 87A&B, 89B, 90B, 91A, 92B, 94A, 103A&B, 104A&B, 114A, 115A, 116A&B, 118A&B, 119A&B, 120A&B, 121A&B, 122A&B, 126A, 127A&B, 128

The photograph on pages 60–61 is provided courtesy of
THE SAN FRANCISCO MARITIME NATIONAL HISTORIC PARK.

Photos on p. 32B, 95B, 108B, and 109A appear courtesy of
KRISTINA DETJEN

The photo on 123B is provided courtesy of
THE MARK HOPKINS INTER-CONTINENTAL HOTEL.

INTRODUCTION

If California ever becomes a prosperous country, this bay will be the center of its prosperity. The abundance of wood and water, the extreme fertility of its shores; the excellence of its climate, which is as near to being perfect as any in the world; and its facilities for navigation, affording the best anchoring grounds in the whole western coast of America, all fit it for a place of great importance.

—— Richard Henry Dana, *Two Years Before the Mast*, 1840

When the tiny harbor village of Yerba Buena was renamed San Francisco in 1847, the first census of the city counted 479 people. By 1848, the number had doubled and the citizens must have felt that their new city was on its way. They would have never guessed that only one year later, the discovery of gold in the Sierra Nevada foothills would bring thousands of "49ers" and the city would be changed forever. By 1852 the population had soared to 34,000.

The prospectors would take more than $100 million worth of gold from the ground, a great deal of which ended up in San Francisco. Although this changed the face of the new city, it was the later discoveries of silver in Nevada (both the Comstock lode in 1859 and the Big Bonanza in 1873) which had an even greater impact on the city. The $500 million of newly created wealth established the city as the cultural and financial center of the West. Montgomery Street was dubbed the "Wall Street of the West".

Seeing its potential as a world-class city, William C. Ralston, who became wealthy with the Comstock silver, invested his fortune and that of his bank in the development of San Francisco. He built the Palace Hotel, the California Theater, a woolen mill, and many other businesses in the city. His vision of San Francisco became a reality, but Mr. Ralston died before many of his undertakings came to fruition. San Franciscans mourned the loss of their "First Citizen."

However, one didn't have to be a wealthy visionary to be taken into the hearts of San Franciscans. Take for example, the story of the city's favorite (and only) monarch. Joshua Abraham Norton arrived in San Francisco in 1849. In time, he made and lost a fortune, then left the city, only to return one day wearing an old blue Army uniform and a plumed hat, proclaiming to be "Norton I, Emperor of the United States and Protector of Mexico." The citizens played along with the eccentric Norton, rising to their feet when he entered the theater, honoring his self-made currency, and extending him credit. Newspapers published his letters, in which he suggested "crazy" ideas at the time, such as building a bridge across the Bay, or decorating an enormous Christmas tree for children in Union Square (both of which came to be). After "Emperor" Norton died while waving to tourists on a Cable Car, more than 30,000 San Franciscans attended his funeral.

The history of the city is filled with so many colorful stories, that it remains a subject of endless fascination for its residents, visitors, and historians alike. In the words of novelist Frank

Norris . . . "There are just three big cities in the United States that are 'story cities'. New York, of course, New Orleans, and best of the lot, San Francisco".

The images in this book capture moments throughout the constantly unfolding story of this great city, beginning with its Gold Rush days and ending in the 1940s. The photographs and postcards provide a glimpse into life as it was at that time and have been chosen to feature scenes, events, and beloved landmarks that portray the atmosphere and magic of "Everyone's Favorite City". I hope you enjoy your journey into the past of this captivating city.

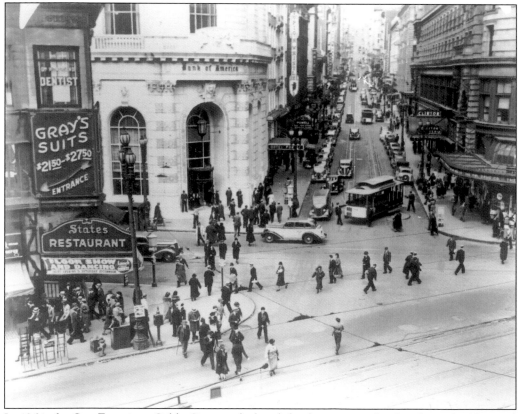

In 1964, the San Francisco Cable Car was declared the first moving landmark on the National Register of Historic Places. This early 1940s photo shows the Powell Street Turntable at the intersection of Powell and Market Streets, where the Powell-Hyde and the Powell-Mason cable cars begin and end their breathtaking routes. The States Restaurant, a popular nightspot with its own orchestra, can be seen on the left.

One

THE INSTANT CITY

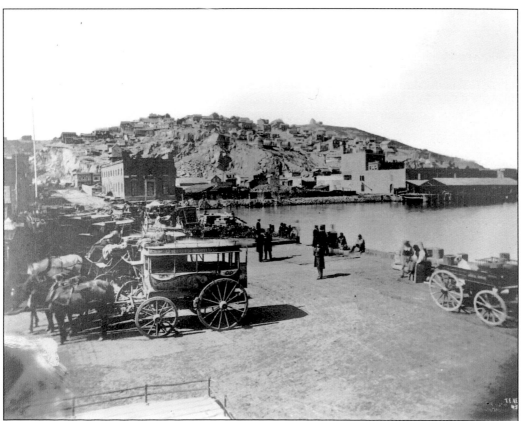

The sleepy town of Yerba Buena was re-christened "San Francisco" in 1847. With the discovery of gold in the Sierra Nevada foothills a year later, the population of the new city quickly reached 20,000. By the time this late 1850s photo was taken showing Telegraph Hill, the gold deposits had grown thin and a post-Gold Rush depression had hit the city. But having survived six major fires and the challenges of starting new lives, the now over 50,000 San Franciscans were on their way to creating what would soon be the financial and cultural center of the west.

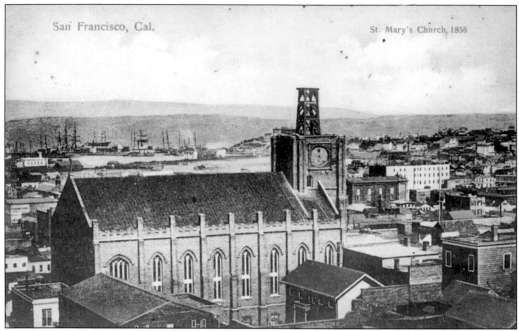

This 1856 photo shows the growing city stretching from St. Mary's Church, the city's first Cathedral, to the harbor. At the time of this photo, the louvered belfry and clock was still under construction. By 1893 a new St. Mary's Cathedral was built on Van Ness Avenue. At that time, this original church, which still stands at California and Grant, became known as "Old" St. Mary's.

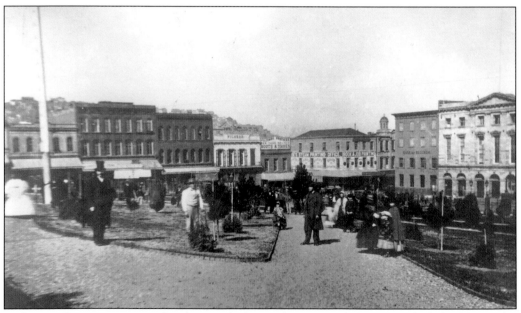

Early San Franciscans pose for this 1865 photo of Portsmouth Square, which had been the central plaza of the Anglo-Mexican settlement of Yerba Buena. It was here that Captain John B. Montgomery first raised the American Flag in 1846, signaling the end of Mexican rule. Two years later Sam Brannan stood in this same square and announced the discovery of gold— igniting gold fever in nearly all of the approximately 900 village inhabitants.

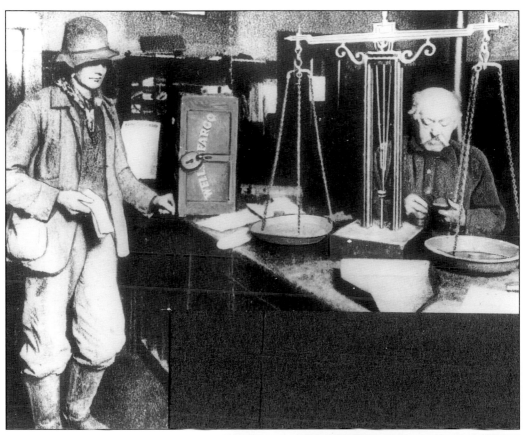

In early 1849, the first Gold Rush ship, the California, arrived in San Francisco Bay filled with "49ers" eager to discover their fortune in gold. Prospectors brought their "finds" into town to be weighed and exchanged for cash. In the photo above, a miner awaits the results of a Wells Fargo Bank employee's calculations. Henry Wells and William G. Fargo, founders of the American Express Company and Wells Fargo Bank, opened their first office in the city in July 1852. Shown at right is the original building on Montgomery Street between California and Sacramento. Wells Fargo also managed the Pony Express, and soon dominated the freight and banking business in the entire west.

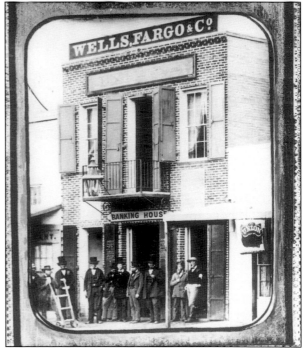

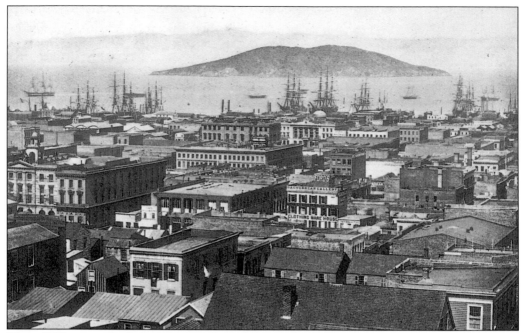

This 1850s view looks across the busy harbor from the intersection of Stockton and Sacramento Streets. San Francisco soon replaced Portland, Oregon, as the major seaport on the west coast.

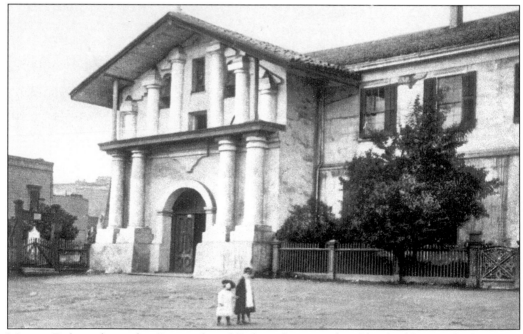

Mission Dolores, located at Sixteenth and Dolores Street, is the oldest building in the Bay area. "Mission San Francisco de Asis" was founded by Father Francisco Palou on June 29, 1776. Built by Indian laborers beginning in 1782, the present mission was completed in 1791. The church has adobe walls four feet thick and has survived four major earthquakes. It was restored by architect Willis Polk in 1920.

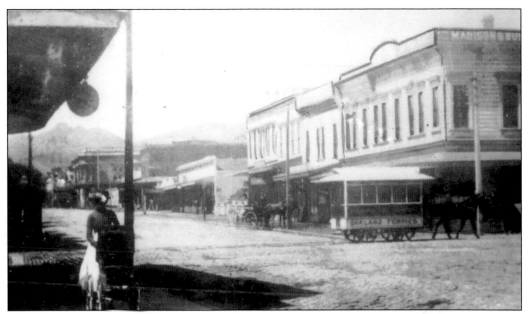

A young mother takes her baby for a stroll at the intersection of Sixteenth and Mission Streets in 1886. The horse-drawn bus shown to the right provided transportation to and from the Oakland Ferries.

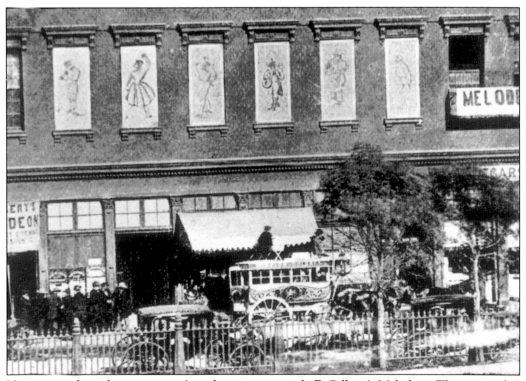

Visitors stand amidst a stagecoach and carriages outside F. Gilbert's Melodeon Theater in this 1854 photo. The Melodeon was located at Clay and Kearny Streets and offered men drinks, cigars, music, and entertainment for the admission price of "two bits" (25¢).

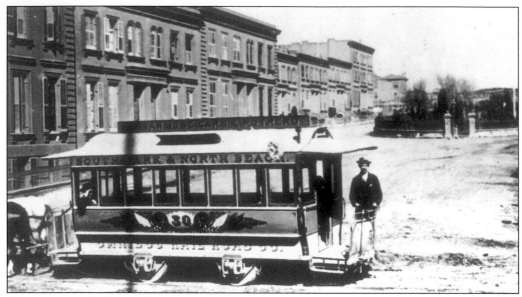

The Omnibus Railroad Company began operating its horse-drawn bus service in 1852. The driver of the car #30 above posed for this 1865 photograph at South Park. Englishman George Gordon created this posh neighborhood with London's Berkeley Square as his inspiration. Until residential development began on Nob Hill, South Park was one of the city's most prestigious locations.

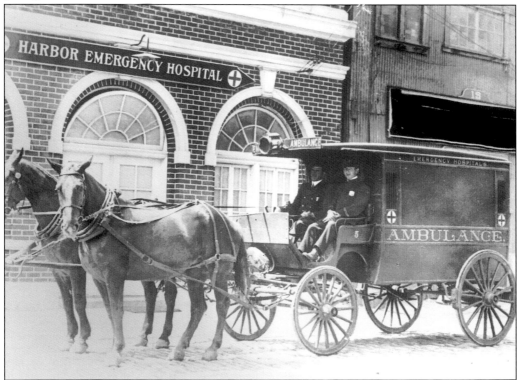

The importance of horses in the early history of San Francisco can hardly be over-emphasized. Here, drivers proudly show off the new horse-drawn ambulance of Harbor Emergency Hospital.

Two

THE LITTLE CABLE CAR THAT COULD

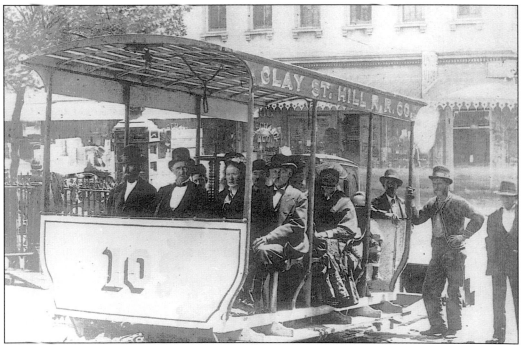

On August 2, 1873, the first cable car traveled down Clay Street with inventor Andrew Halladie as the gripman. In this photo, showing one of his original Clay Street Hill Railroad Company cable cars, Mr. Halladie and his wife Mattie are seated in the front row with Mayor A.J. Bryant seated between them.

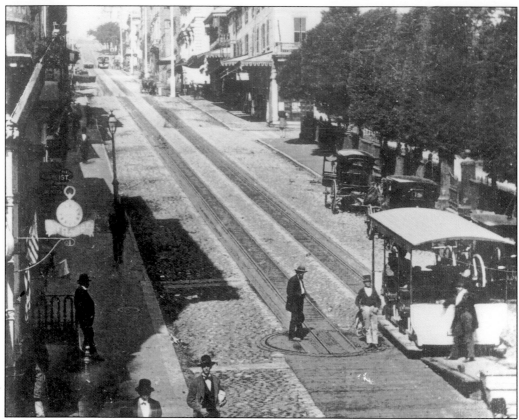

The first cable car route was established and operated by Hallidie's Clay Street Hill Railroad Company in 1873. It remained the city's only line for four years. Shown here is the terminus of the route at the intersection of Clay and Kearny Streets.

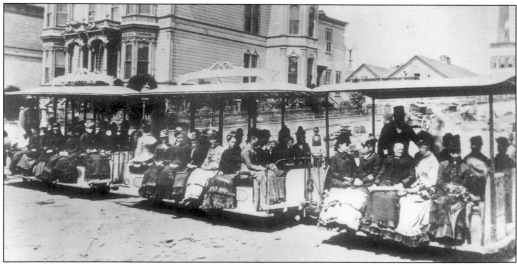

The cable cars were enthusiastically embraced by the public, as witnessed in this 1877 photo. This three-car "Shopper's Special" was filled with women when it was photographed at the corner of Larkin and Sutter Streets.

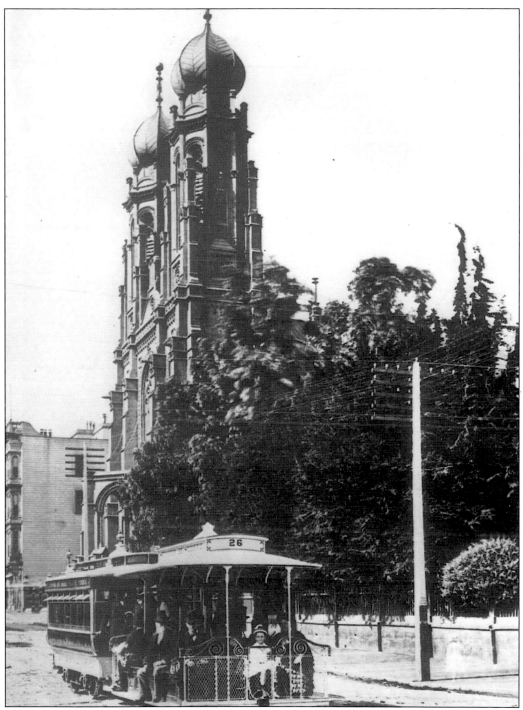

Sutton Street Car #26 was filled with passengers when this 1882 photograph was taken in front of Temple Emanu-El. The temple, completed in the 1860s, was the second building to house the historic congregation. It was extensively damaged in the 1906 Earthquake and in 1926, the Reformed Congregation relocated to the Temple Emanu-El at Arguello and Lake Boulevards. Today the Art Deco "450 Sutter" building stands on the former site of the temple.

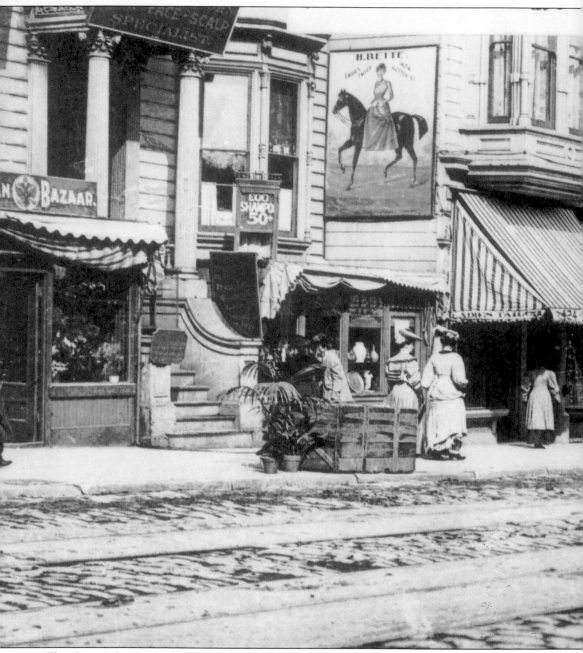

The Sutter Street Railway, the city's second cable car line, ran from Market, Sutter, and Sansome Streets to the powerhouse on Larkin and Bush. Owner Henry Casebolt converted

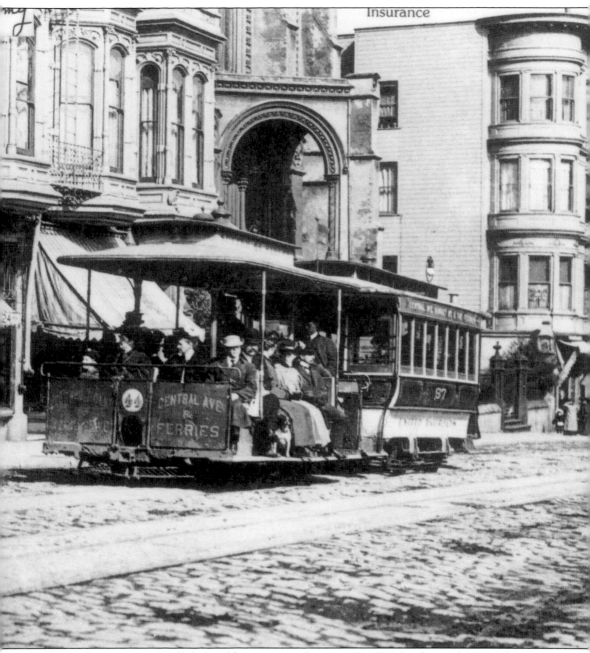

his horse-drawn cars to Hallidie's cable system on January 27, 1877. In this mid-1880s photo, a Sutter Street cable car passes the many shops that opened along its route.

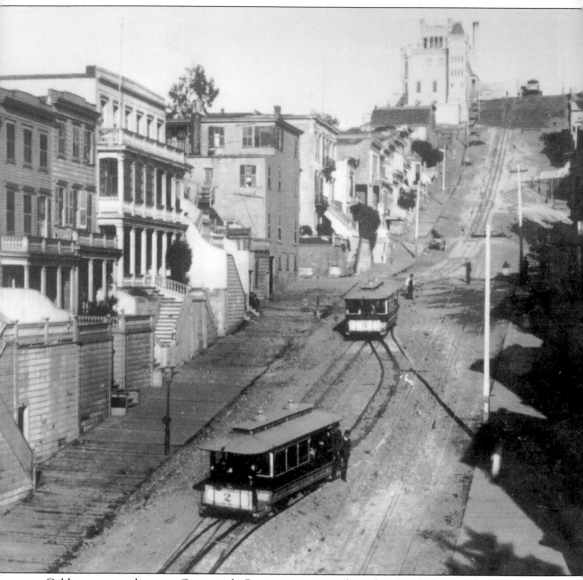

Cable cars traveling on Greenwich Street are captured in this 1884 photo. The old German Castle, shown at the top of Telegraph Hill, was built in 1882 by Frederick Layman, who intended it to be a stylish resort. However, the business floundered after a fatal wreck on Layman's private cable car line and the castle burned in 1903.

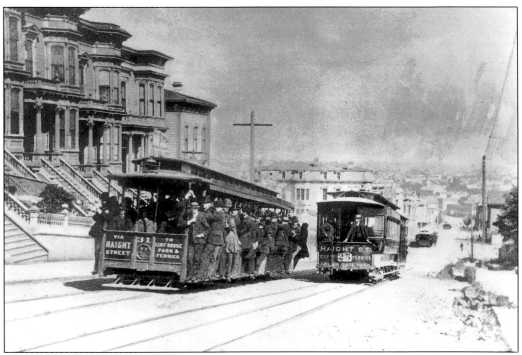

Passengers enjoy "riding the rope," as a trip aboard the cable car was often called. This 1887 photo, taken on Haight Street between Buchanan and Octavia Streets, shows both the open and closed models of the Market Street Railway Company cars.

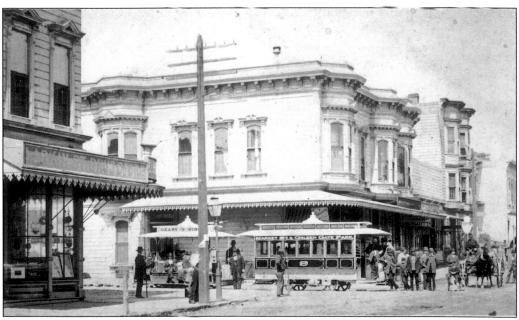

Charming Victorian homes provide the background as passengers exit the cable car at the intersection of Geary and Larkin Streets. The Larkin Street Drug Store can be seen on the left. By 1890, eight cable car companies ran six hundred cars over 100 miles of track throughout the City.

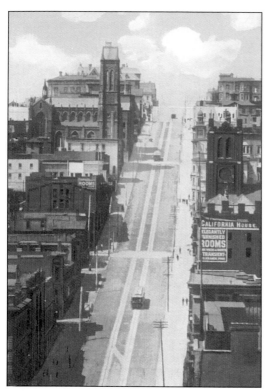

In early days, the cable car lines were owned by private companies. The California Street firm introduced a car with a driver's cab at either end. This eliminated the need to be turned around on the famous turntables at the end of each run. Of the three lines existing today, the California Street cable cars are the only "two-way" models. In this c. 1900 view, a cable car climbs the California Street hill. The landmark Fairmont hotel had not yet been constructed.

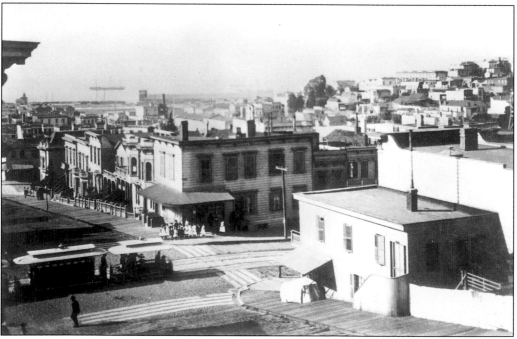

A woman, possibly a teacher, and a large group of children wait on the corner as a cable car passes them on Union Street. The area was once part of Cow Hollow, where herds of dairy cattle grazed. Today, Union Street is a vibrant street filled with shops and restaurants in lovely, restored Victorian settings.

Three

THE CITY BEFORE
APRIL 18, 1906

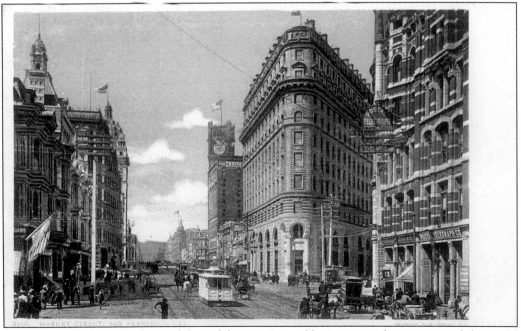

Market Street, the main thoroughfare of the town's retail business, was known around the world by the time of this c. 1905 postcard. The original Palace Hotel can be seen on the right, with the flatiron Crocker Building just beyond it. In the distance is the San Francisco Chronicle building with its easily identifiable clock tower.

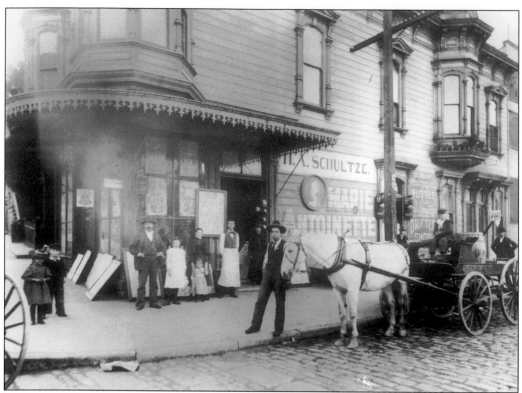

The proprietor, his family, and employees of this neighborhood store on the corner of Turk and Larkin Streets take time out for a photograph.

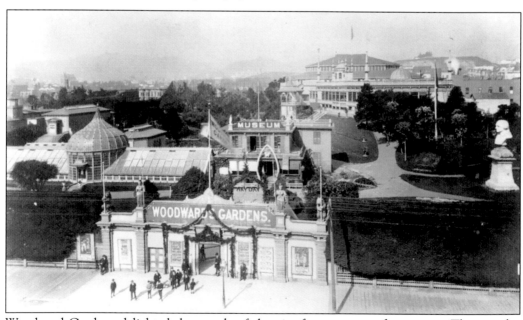

Woodward Gardens delighted the people of the city for a quarter of a century. The popular resort, shown in this 1875 photo, was located at Fourteenth and Mission Street and offered a variety of amusements such as a zoo, botanical gardens, and balloon rides.

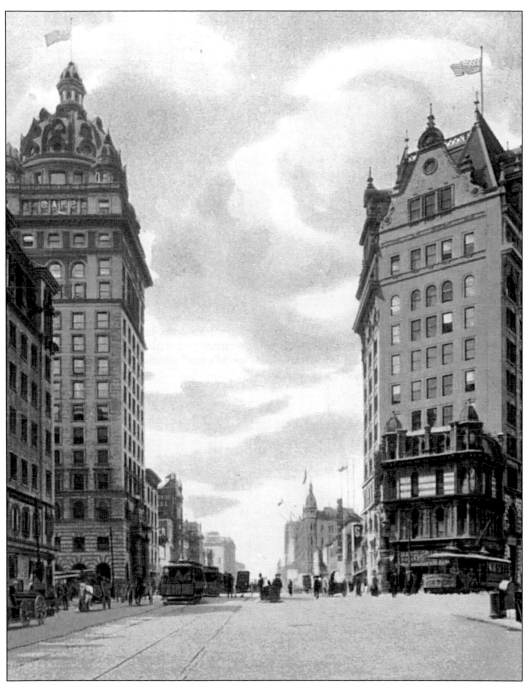

Two of the city's most impressive skyscrapers are featured in this c. 1905 postcard. On the left is the Call Building, which was the tallest building in the city at that time. Designed in 1898 by the Reid Brothers, it is known today as the Central Tower. The 12-story Mutual Bank Building, designed by architect William Curlett, is shown on the right. The building was completed in 1902 and would later be known as the Citizens Savings and Loan Building. Both buildings would survive the Earthquake of 1906 but be gutted by fire. Successfully renovated, they are part of the San Francisco skyline today.

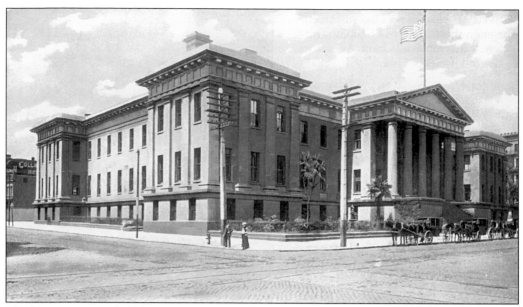

The large amount of gold coming into the city in the 1860s outgrew the capacity of the earlier mint. "Old Mint," shown in this *c.* 1905 postcard, was completed in 1874 and built so well that when the 1906 Earthquake turned its neighboring buildings to rubble, the Mint remained undamaged. Citizens and soldiers heroically fought back the flames that lapped at the iron shutters and exterior, saving the $200 million inside. In 1937, the operations were moved to a larger building on Market Street. Restored at a cost of $2 million in the 1970s, Old Mint is now a museum operated by the National Park Service.

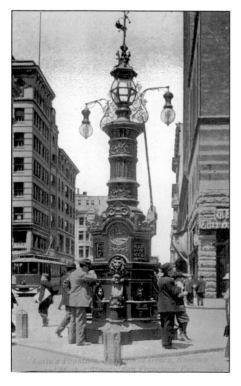

Lotta's Fountain, located at the junction of Geary, Kearny and Market Streets, is named after Lotta Crabtree. The popular local singer and daughter of a gold miner eventually went on to fame and fortune on Broadway. She donated the fountain to her favorite city in 1875.

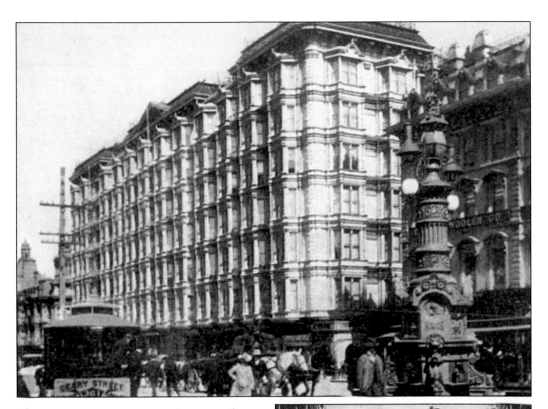

This c. 1904 postcard shows the original Palace Hotel with Lotta's Fountain in the right foreground. When Bank of California founder William C. Ralston opened the hotel on October 2, 1875, it was the largest and most luxurious hotel in the city and was considered by many the most lavish hotel in the world.

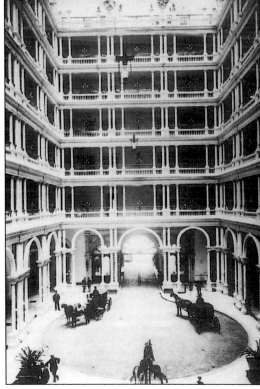

The vast seven-story Grand Court of the Palace Hotel, surrounded by interior balconies, could accommodate the horse-drawn carriages of arriving guests. When the hotel was rebuilt after the 1906 Fire, this space was converted to the famous Garden Court, which is now an historic landmark.

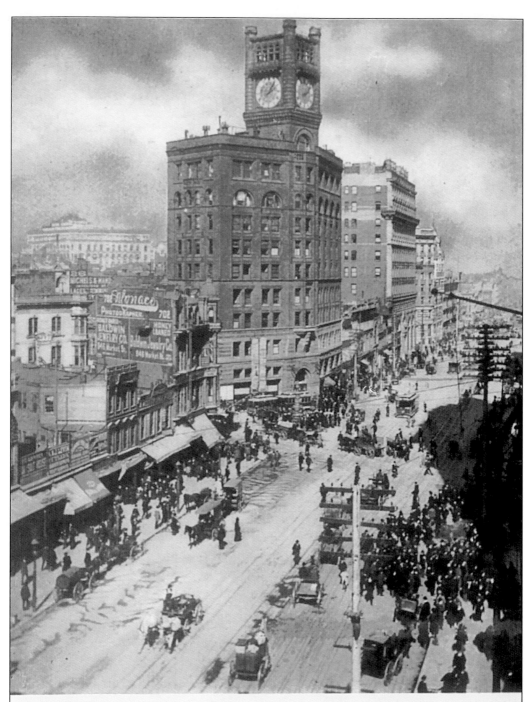

SAN FRANCISCO, CALIFORNIA
MARKET STREET

The Chronicle Building, with its stately clock tower, can be seen in this 1901 photo of Market Street. The ten-story building, home to the *San Francisco Chronicle*, was dedicated on June 10, 1890.

The street-side flower business began in the city in the 1880s when a group of children (mostly Italian, Belgian, and Armenian immigrants) operated their stands outside the *San Francisco Chronicle* Building.

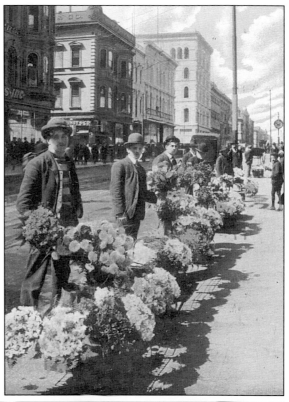

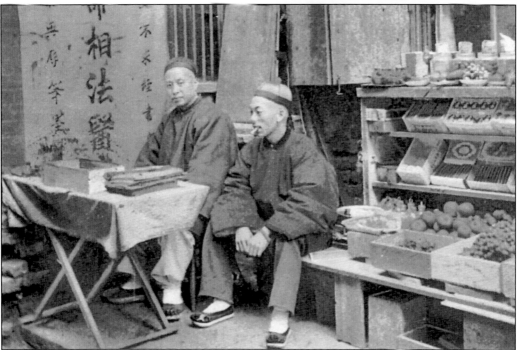

A postcard dated January 13, 1906, shows sidewalk merchants awaiting customers at their vegetable and fruit stand in Chinatown.

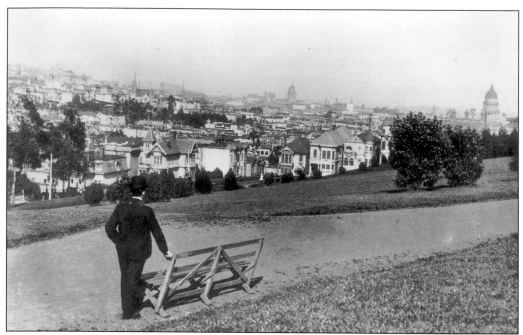

A lone visitor at Alamo Square takes in the spectacular view of downtown from Hayes and Steiner Streets. The dome of City Hall can be seen in the distance on the far right.

The excitement shows on the face of Mr. Henry Louis Detjen in this 1900 photograph as he prepares to leave for a 30-day vacation in Yosemite National Park with his four best friends. Sadly, one of the group was killed in a wagon accident on the trip home, an example of the hazardous travel conditions of the times.

Levi Strauss came to San Francisco during the Gold Rush to sell goods to prospectors. After hearing miners complain that their pants didn't last, Strauss used the canvas meant for tents to create more durable trousers. Instantly successful, he eventually switched from canvas to a tough blue cotton that is known today as denim. The letters SF on the rivets of the jeans stands for the city, where the company still operates today. The photograph to the right shows an employee sewing at the Levi Strauss factory around the turn of the 20th century.

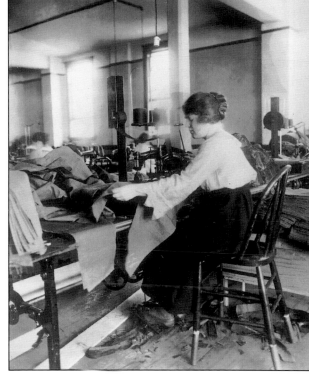

Early San Franciscans were hard at work preparing tracks for the electric streetcars in this 1905 photograph taken at Mission and Twenty-Second Street.

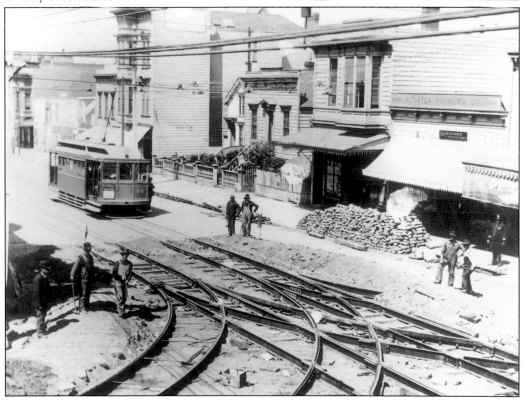

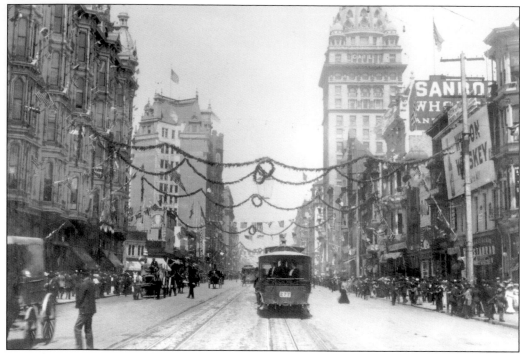

A Market Street cable car passes under the festive decorations on Christmas Day, 1903. On the immediate left is the original bay-windowed Palace Hotel. The domed Call Building can be seen clearly on the right. The dome was removed during an extensive renovation in the 1940s. The building is known today as the Central Tower.

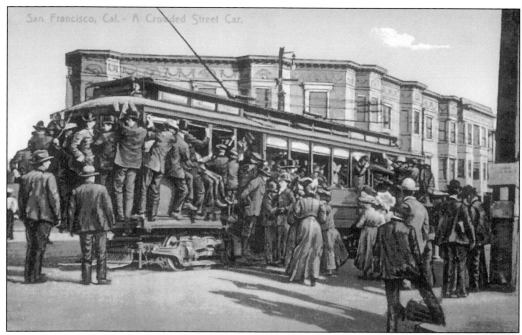

By the 1890s, electric streetcar lines began replacing some of the cable car routes. This 1902 postcard shows the heavy dependence on public transportation.

The Flood Building, designed in 1906, is an example of the neo-classical architectural style popular around the turn of the century. Built on the corner of Market and Powell Streets, the building was named for James C. Flood. Architect Albert Pissis designed the 12-story structure as part of the "City Beautiful" Movement, adding decorative motifs that reflected the architectural detailing of the nearby Emporium, which he had built a decade earlier. The Emporium, shown below in this c. 1906 postcard, was the largest department store in the city at the time.

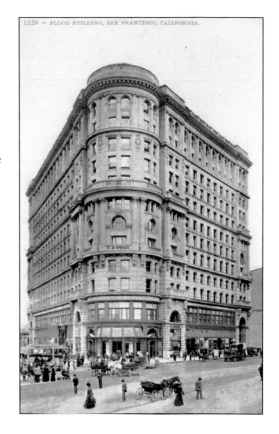

1229 – FLOOD BUILDING, SAN FRANCISCO, CALIFORNIA.

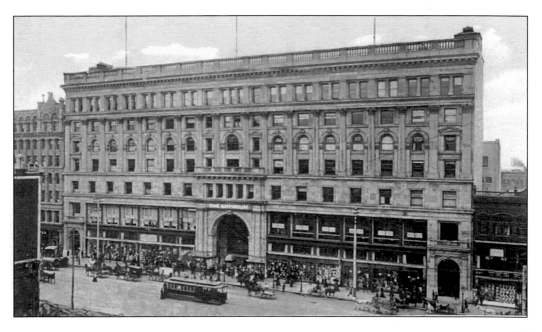

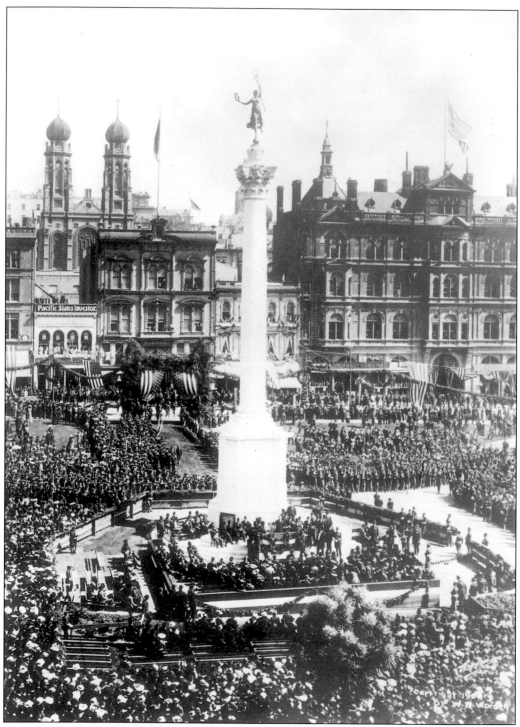

Crowds filled Union Square in 1903 when President Theodore Roosevelt dedicated the 90-foot monument commemorating Admiral George Dewey's victory at Manila Bay during the Spanish American War. San Franciscan Alma de Bretteville Spreckels was the model for the Robert I. Aitkens bronze figure of "Victory," which graces the top of the column.

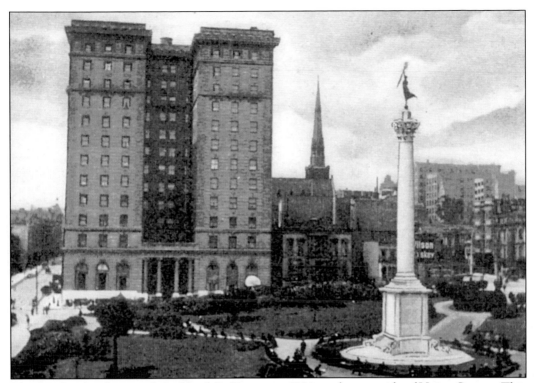

The Crocker family opened the Hotel St. Francis in 1904 on the west side of Union Square. This scene provides a pre-earthquake view of the hotel and Union Square, which was named for the pro-Union rallies held there during the Civil War. Shown in the foreground is the Dewey monument.

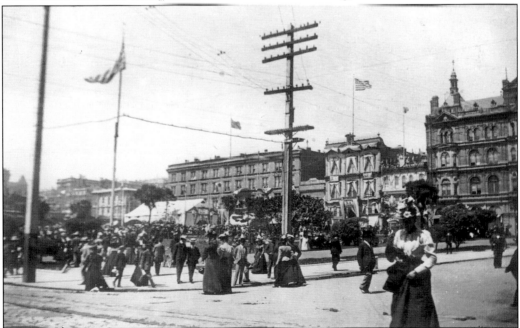

By the late 1800s, San Francisco's leading retail stores had moved to Union Square, starting a shopping tradition which continues today.

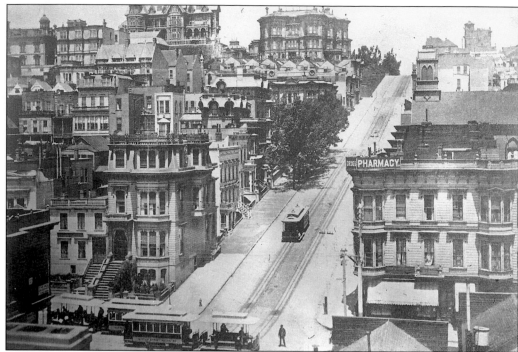

Cable cars on Sutter and Powell Streets cross paths in this 1896 view which shows building growth atop Nob Hill. At the top of the hill on the left of Powell St. are the mansions of Leland Stanford and Mark Hopkins. Both mansions were destroyed by the 1906 Fire and are now the sites of fine hotels bearing their names.

Despite the availability of public transportation, this turn-of-the-century photograph of Clement Street in the Richmond district shows that the horse still played a major role in day-to-day activities.

The Fairmont Hotel can be seen at the top of Nob Hill in this 1904 postcard looking westward up California Street. Old St. Mary's Church can be seen just below the landmark hotel, which was still under construction at that time.

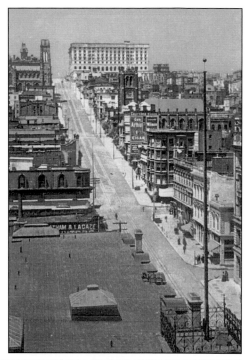

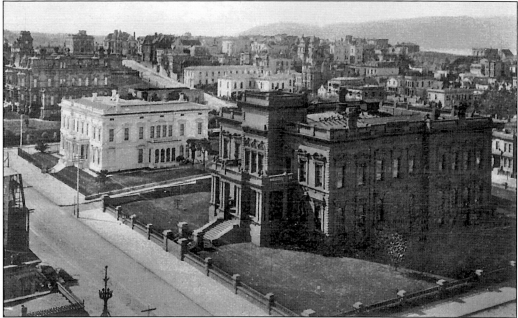

Some of the palatial mansions built on Nob Hill are shown on this c. 1904 postcard. In the foreground is the home of James C. Flood, who, after seeing brownstone mansions in New York, chose the sturdy material for his home. It was a wise choice, as it was the only residence on Nob Hill to survive the 1906 fire. Today it is home to the prestigious Pacific-Union Club. The mansion to the left is that of Collis P. Huntington, whose widow donated the site to become Huntington Park. Beyond that stands the Charles Crocker mansion. After the fire, the Crocker family donated the land to the Episcopal Church, and Grace Cathedral stands on the site today.

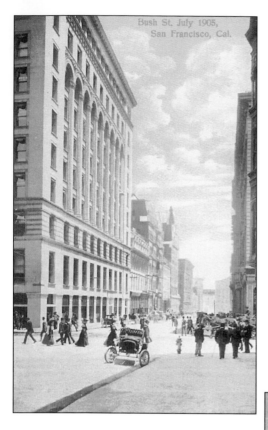

This 1905 postcard shows one of the first automobiles in the city parked on Bush Street. In the early days of the automobile there were no gas stations. Gasoline was sold in drug stores for 60¢ a gallon and it was customary to carry two 5-gallon cans for reserve in the car. The 1890 Mills Building, which today is the city's oldest skyscraper, is seen to the left.

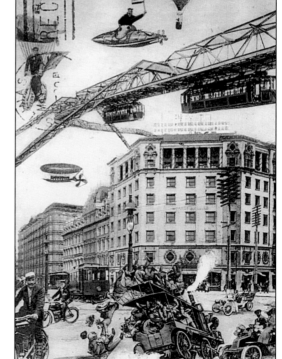

The increase in vehicle traffic prompted cartoons such as the one on this 1905 postcard. The imaginative artist predicted what Market Street might be like in 50 years.

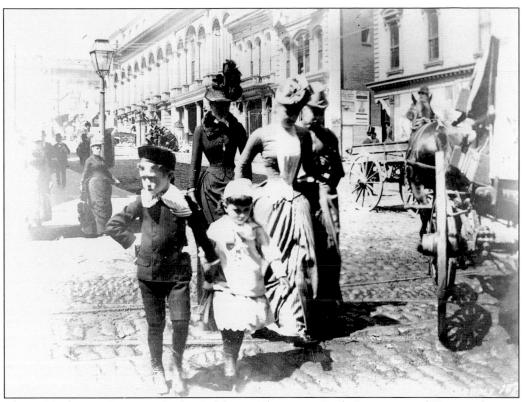

This 1877 photo, taken outside the California Theater on Bush Street west of Kearny, shows a family dressed for a day at the matinee.

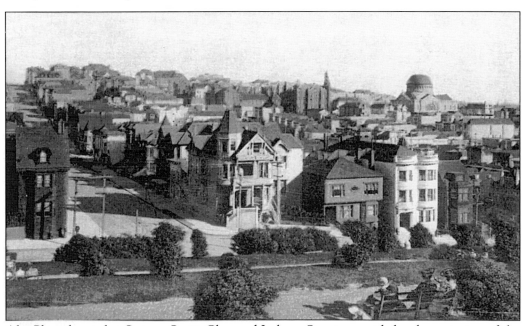

Alta Plaza, located at Steiner, Scott, Clay, and Jackson Streets, provided a pleasant view of the city in this early 1900s postcard.

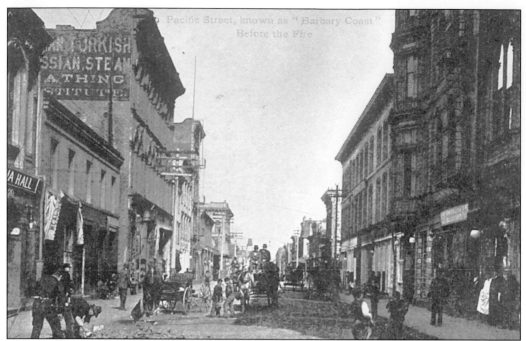

This c. 1900 photo shows Pacific Street, then part of the "Barbary Coast." The notorious red light district was home to brothels, gambling halls, and opium dens. Closed down by Federal Decree in 1917, the area today is part of fashionable Jackson Square.

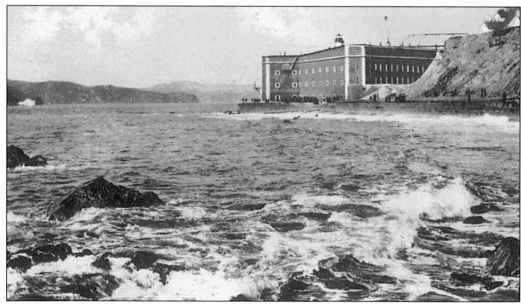

Fort Winfield Scott is shown in this c. 1904 postcard. The brick fortress at Fort Point was completed in 1861, replacing the Castillo de San Joaquin built by the Spanish at the same location in 1794. In 1971 a year-long restoration was completed and the fort is now a National Historic Site and part of the National Park Service.

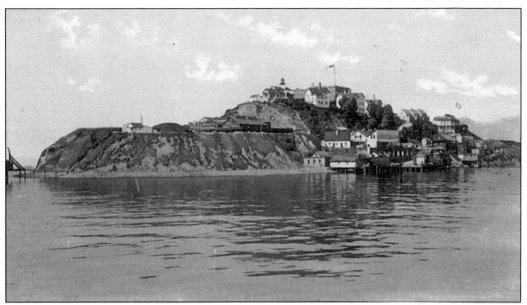

Alcatraz Island housed a military prison from 1861 until 1933, when it became a federal penitentiary. At the time of this turn-of-the-century postcard, it held prisoners from the Spanish American War. "Alcatraz" means pelican in Spanish, referring to the first inhabitants of the island. It was later called "The Rock" by inmates such as Al Capone, "Machine Gun" Kelly, and Robert "The Birdman" Stroud. Alcatraz is now part of the Golden Gate National Recreation Area.

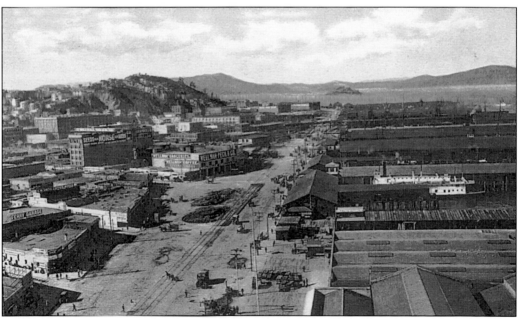

Old East Street, as seen from the Ferry Tower, eventually became today's Embarcadero. The wooden wharves seen to the right in this photo have long since been replaced by concrete piers.

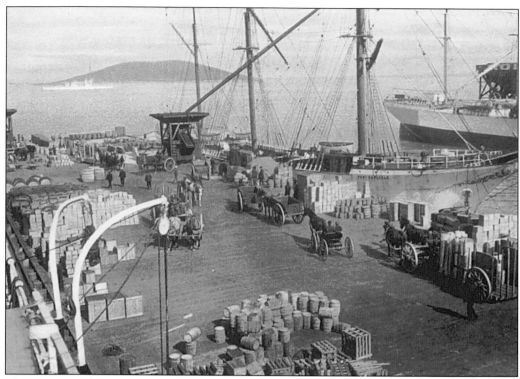

The commercial importance of San Francisco grew rapidly. By the late 1800s the Vallejo Street Wharf was filled with activity. Goat Island can be seen in the background.

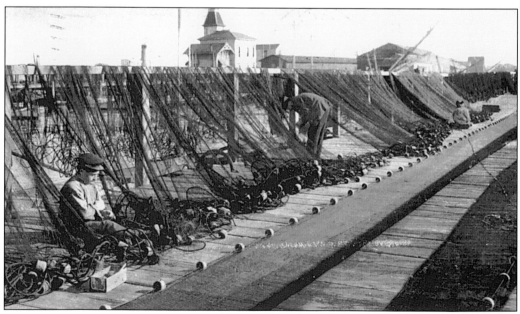

As their fishnets dry over the railing, Italian fishermen are busy making the necessary repairs for the next day's catch. At the time of this c.1900 postcard, Fisherman's Wharf was located at the foot of Union Street.

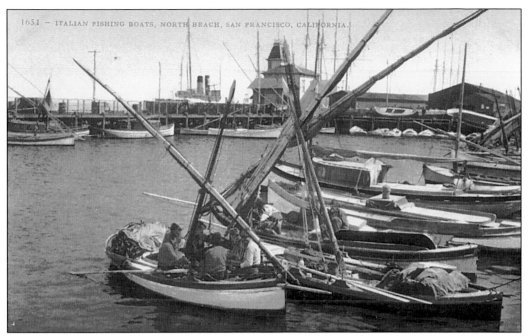

Fishermen gather aboard the Italian fishing boats, or feluccas, shown here moored in North Beach in the early 1900s.

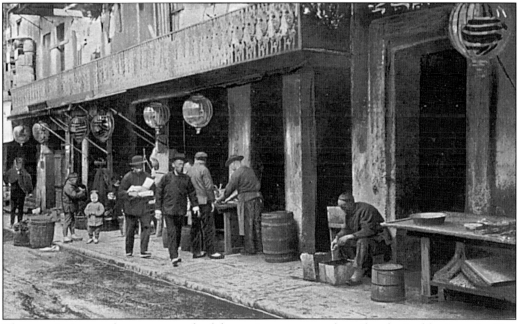

The proximity to the ocean made fish an important and easily obtainable item in San Franciscan's diet. This 1903 postcard shows "Fish Alley," where citizens of Chinatown shopped for fresh seafood.

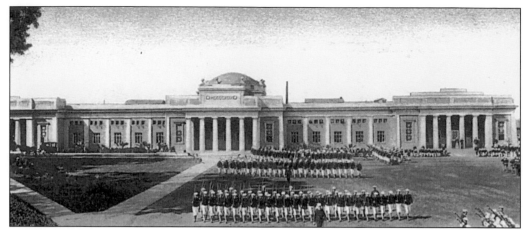

A U.S. Naval Training Station was established on Yerba Buena Island by President William McKinley in April 1898. This 1902 postcard shows an impressive barracks, which housed 500 trainees.

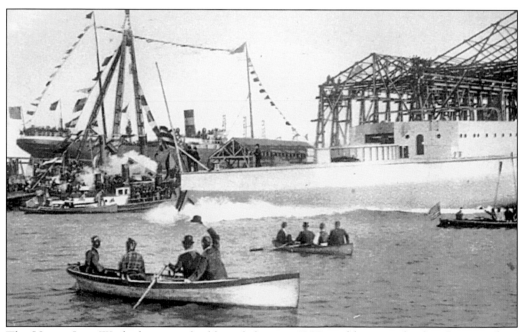

The Union Iron Works began to build steel ships in 1883, and became the first large modern shipyard on the west coast. This early view shows the launching of the monitor "Monterey," built for the United States Navy on April 28, 1891.

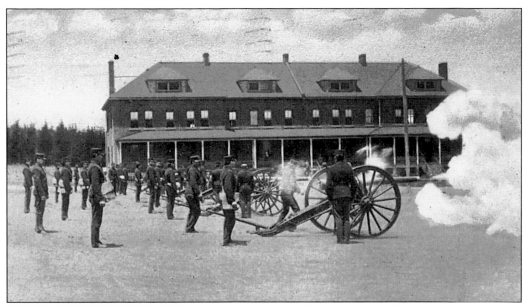

The Presidio, originally founded by the Spanish in 1776, became a United States military installation in 1847. It remained so until 1995 when it was turned over to the National Park Service. This pre-World War I postcard shows artillery men conducting the Morning Salute.

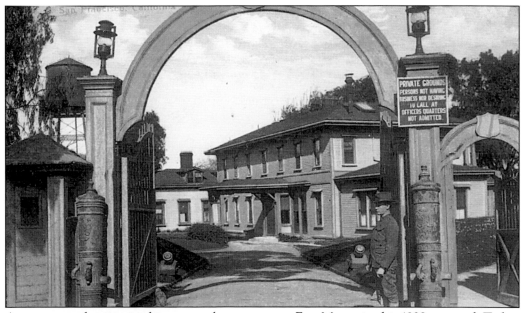

An army guard maintains his post at the entrance to Fort Mason in this 1908 postcard. Today, the fort is Park Headquarters for the Golden Gate National Recreation Area. The site of museums, shops, and galleries, it is also one of the city's most important cultural centers.

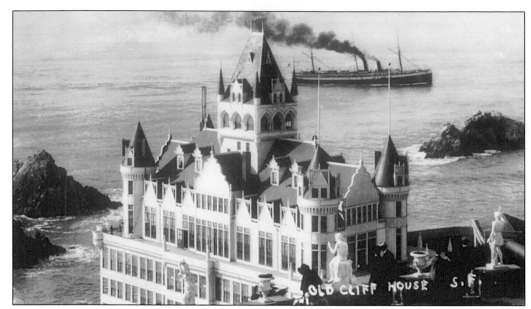

The Pacific Coast Steamship Company's *Santa Rosa* approaches San Francisco past the old Cliff House and Seal Rocks. The 326-foot long steamship was the pride of the fleet in the 1880s. At the time of this turn-of-the-century photograph, she was a standby of the San Francisco-San Diego Express Service.

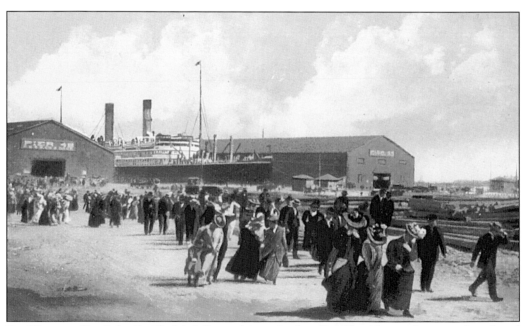

On "Steamer Day," the Pacific Mail Steamship arrived at Pier 42 with eagerly awaited mail and newspapers from the east coast.

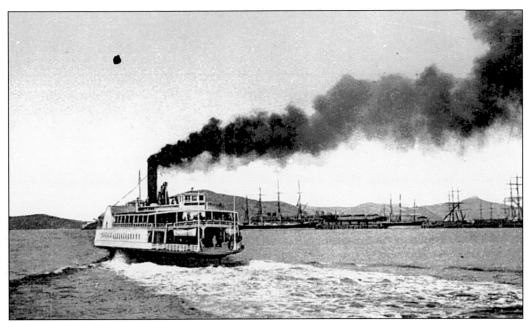

This view shows a ferry boat performing the essential service of transporting passengers across the bay. With the opening of the Bay Bridge in 1936, use of the ferries began a long period of decline, and service finally ended in 1958. In the 1970s service was re-established to Marin County and the East Bay.

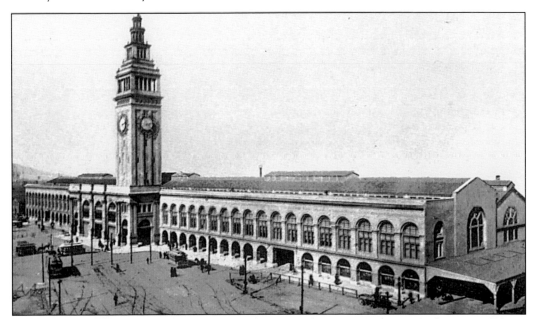

The Union Ferry Depot was the gateway to the city at the time. Architect Arthur Paige Brown designed the depot in 1898 with a 235-foot clock tower modeled after the Giralda Tower of Spain's Seville Cathedral. The clocks on the tower stopped at the precise times of both the 1906 and 1989 Earthquakes. In the mid-1930s, before the opening of the Bay Bridge, over 50 million passengers passed through the depot in a single year—a record surpassed only by Charing Cross Station in London.

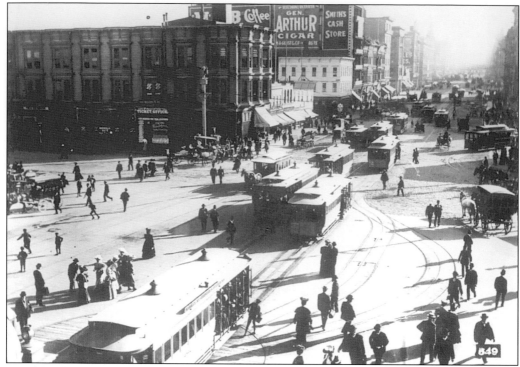

You didn't have to wait long for a cable car when this 1905 photo was taken showing Market Street looking west from the Ferry Building. During the height of the cable car era, 8 different cable car companies ran 600 cars over more than 100 miles of track. During the rebuilding after the Earthquake and Fire of 1906, many more cable cars were replaced with electric streetcars.

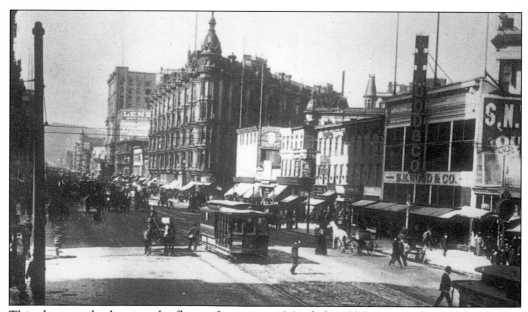

This photograph, showing the flurry of activity on March 31, 1906, gives no hint of the disaster soon to befall the city. Eighteen days later, the Great Earthquake and Fire would destroy every building shown, including the original Palace Hotel in the center of this scene.

Four

DISASTER STRIKES

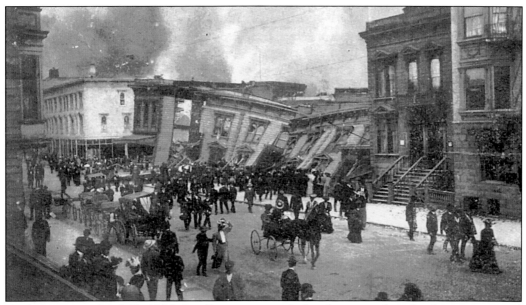

At 5:12 a.m. on April 18, 1906, San Francisco was shaken by an earthquake that is estimated today to have been 8.25 on the Richter scale. Buildings collapsed and debris rained into the streets, but the greatest damage by far was caused by the fires that followed. The city burned for three days before the fire was brought under control. The photograph above shows residents fleeing near Hyde Street as the fire approaches.

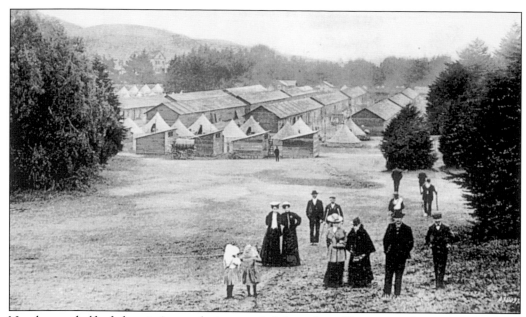

Nearly one half of the city's population was left homeless. The city parks provided refugee camps where tents and shelters were erected.

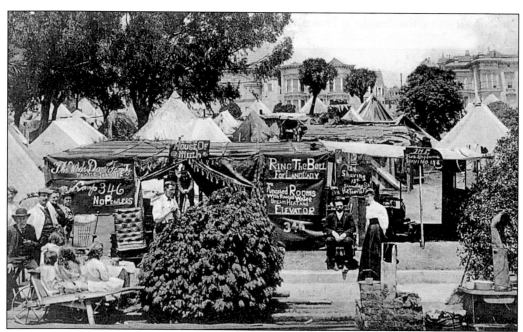

Many chose to build their own temporary housing, such as these residents photographed in Jefferson Square in May 1906. Despite the adversity, a sense of humor prevailed as they hung signs advertising "furnished rooms with running water, steam heat, and elevator" or reading "Ring the bell for Landlady." Another refugee called his humble abode "The House of Mirth."

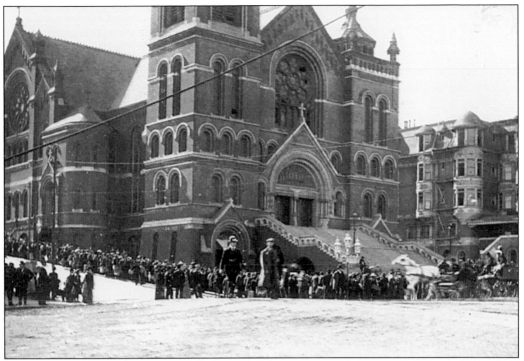

Crowds waited in the bread line at St. Mary's Cathedral on Van Ness Avenue. On the back of this postcard, the sender writes that "although the Cathedral was just outside the fire line, the steeple did catch fire but was saved by a hero."

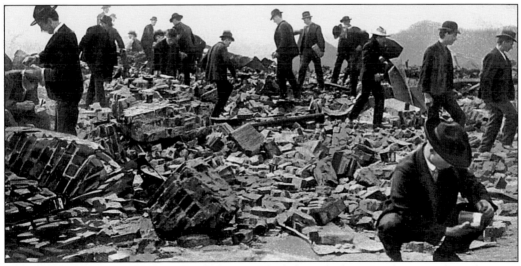

With food in short supply, formally clad men picked through the ruins for canned goods.

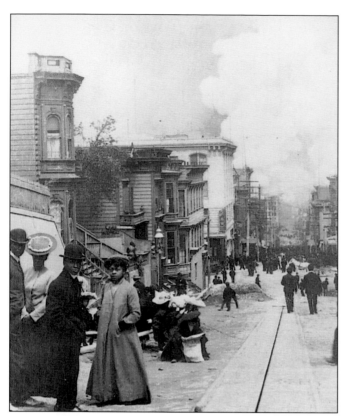

Despite all the destruction and danger, there were very few reports of panic. Overall, the residents remained calm as the fire continued to spread.

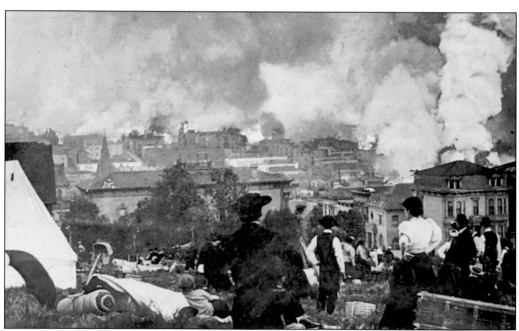

Citizens gathered in a Refugee camp in Lafayette Park look on as their city becomes an inferno. Looking from Gough and Clay, they watch as the fire spreads down Russian Hill towards Van Ness Ave.

The Call-Chronicle-Examiner

SAN FRANCISCO, THURSDAY, APRIL 19, 1906.

EARTHQUAKE AND FIRE SAN FRANCISCO IN RUINS

DEATH AND DESTRUCTION HAVE BEEN THE FATE OF SAN FRANCISCO. SHAKEN BY A TEMBLOR AT 5:13 O'CLOCK YESTERDAY MORNING, THE SHOCK LASTING 48 SECONDS AND SCOURGED BY FLAMES THAT RAGED DIAMETRICALLY IN ALL DIRECTIONS, THE CITY IS A MASS OF SMOULDERING RUINS. AT SIX O'CLOCK LAST EVENING THE FLAMES SEEMINGLY PLAYING WITH INCREASED VIGOR, THREATENED TO DESTROY SUCH SECTIONS AS THEIR FURY HAD SPARED DURING THE EARLIER PORTION OF THE DAY. BUILDING THEIR PATH IN A TRIANGULAR CIRCUIT FROM THE START IN THE EARLY MORNING, THEY JOCKEYED AS THE DAY WANED, LEFT THE BUSINESS SECTION, WHICH THEY HAD ENTIRELY DEVASTATED, AND SKIPPED IN A DOZEN DIRECTIONS TO THE RESIDENCE PORTIONS. AS NIGHT FELL THEY HAD MADE THEIR WAY OVER INTO THE NORTH BEACH SECTION AND SPRINGING ANEW TO THE SOUTH THEY REACHED OUT ALONG THE SHIPPING SECTION DOWN THE BAY SHORE, OVER THE HILLS AND ACROSS TOWARD THIRD AND TOWNSEND STREETS. WAREHOUSES, WHOLESALE HOUSES AND MANUFACTURING CONCERNS FELL IN THEIR PATH. THIS COMPLETED THE DESTRUCTION OF THE ENTIRE DISTRICT KNOWN AS THE "SOUTH OF MARKET STREET." HOW FAR THEY ARE REACHING TO THE SOUTH ACROSS THE CHANNEL CANNOT BE TOLD AS THIS PART OF THE CITY IS SHUT OFF FROM SAN FRANCISCO PAPERS.

AFTER DARKNESS, THOUSANDS OF THE HOMELESS WERE MAKING THEIR WAY WITH THEIR BLANKETS AND SCANT PROVISIONS TO GOLDEN GATE PARK AND THE BEACH TO FIND SHELTER. THOSE IN THE HOMES ON THE HILLS JUST NORTH OF THE HAYES VALLEY WRECKED SECTION PILED THEIR BELONGINGS IN THE STREETS AND EXPRESS WAGONS AND AUTOMOBILES WERE HAULING THE THINGS AWAY TO THE SPARSELY SETTLED REGIONS. EVERYBODY IN SAN FRANCISCO IS PREPARED TO LEAVE THE CITY, FOR THE BELIEF IS FIRM THAT SAN FRANCISCO WILL BE TOTALLY DESTROYED.

DOWNTOWN EVERYTHING IS RUIN. NOT A BUSINESS HOUSE STANDS. THEATRES ARE CRUMBLED INTO HEAPS. FACTORIES AND COMMISSION HOUSES LIE SMOULDERING ON THEIR FORMER SITES. ALL OF THE NEWSPAPER PLANTS HAVE BEEN RENDERED USELESS, THE "CALL" AND THE "EXAMINER" BUILDINGS, EXCLUDING THE "CALL'S" EDITORIAL ROOMS ON STEVENSON STREET BEING ENTIRELY DESTROYED.

IT IS ESTIMATED THAT THE LOSS IN SAN FRANCISCO WILL REACH FROM $150,000,000 TO $200,000,000. THESE FIGURES ARE IN THE ROUGH AND NOTHING CAN BE TOLD UNTIL PARTIAL ACCOUNTING IS TAKEN.

ON EVERY SIDE THERE WAS DEATH AND SUFFERING YESTERDAY. HUNDREDS WERE INJURED, EITHER BURNED, CRUSHED OR STRUCK BY FALLING PIECES FROM THE BUILDINGS AND ONE OF TEN DIED WHILE ON THE OPERATING TABLE AT MECHANICS' PAVILION, IMPROVISED AS A HOSPITAL FOR THE COMFORT AND CARE OF 350 OF THE INJURED. THE NUMBER OF DEAD IS NOT KNOWN BUT IT IS ESTIMATED THAT AT LEAST 500 MET THEIR DEATH IN THE HORROR.

AT NINE O'CLOCK, UNDER A SPECIAL MESSAGE FROM PRESIDENT ROOSEVELT, THE CITY WAS PLACED UNDER MARTIAL LAW. HUNDREDS OF TROOPS PATROLLED THE STREETS AND DROVE THE CROWDS BACK, WHILE HUNDREDS MORE WERE SET AT WORK ASSISTING THE FIRE AND POLICE DEPARTMENTS. THE STRICTEST ORDERS WERE ISSUED, AND IN TRUE MILITARY SPIRIT THE SOLDIERS OBEYED. DURING THE AFTERNOON THREE THIEVES MET THEIR DEATH BY RIFLE BULLETS WHILE AT WORK IN THE RUINS. THE CURIOUS WERE DRIVEN BACK AT THE BREASTS OF THE HORSES THAT THE CAVALRYMEN RODE AND ALL THE CROWDS WERE FORCED FROM THE LEVEL DISTRICT TO THE HILLY SECTION BEYOND TO THE NORTH.

THE WATER SUPPLY WAS ENTIRELY CUT OFF, AND MAY BE IT WAS JUST AS WELL, FOR THE LINES OF FIRE DEPARTMENT WOULD HAVE BEEN ABSOLUTELY USELESS AT ANY STAGE. ASSISTANT CHIEF DOUGHERTY SUPERVISED THE WORK OF HIS MEN AND EARLY IN THE MORNING IT WAS SEEN THAT THE ONLY POSSIBLE CHANCE TO SAVE THE CITY LAY IN EFFORT TO CHECK THE FLAMES BY THE USE OF DYNAMITE. DURING THE DAY, A BLAST COULD BE HEARD IN ANY SECTION AT INTERVALS OF ONLY A FEW MINUTES, AND BUILDINGS NOT DESTROYED BY FIRE WERE BLOWN TO ATOMS. BUT THROUGH THE GAPS MADE THE FLAMES JUMPED AND ALTHOUGH THE FAILURES OF THE HEROIC EFFORTS OF THE POLICE FIREMEN AND SOLDIERS WERE AT TIMES SICKENING, THE WORK WAS CONTINUED WITH A DESPERATION THAT WILL LIVE AS ONE OF THE FEATURES OF THE TERRIBLE DISASTER. MEN WORKED LIKE FIENDS TO COMBAT THE LAUGHING, ROARING, ONRUSHING FIRE DEMON.

NO HOPE LEFT FOR SAFETY OF ANY BUILDINGS

San Francisco seems doomed to entire destruction. Well ...

Continued on Page Two

BLOW BUILDINGS UP TO CHECK FLAMES

The dynamiting of buildings in the track of the fire, to stay the progress of the flames, was in charge of John Bermingham, Jr., superintendent of the California Powder Works. ...

next of Kearny street.

WHOLE CITY IS ABLAZE

At 12 o'clock last night the Grand hotel was destroyed by the flames which passed unchecked across Montgomery street and attacked the block bounded by Montgomery, Bush, Sutter and Sansome. ...

CHURCH OF SAINT IGNATIUS IS DESTROYED

The magnificent church and College of St. Ignatius on the southwest corner of Van Ness avenue and Hayes street represents in its destruction a material loss of over $1,000,000. ...

MAYOR CONFERS WITH MILITARY AND CITIZEN

At 1 o'clock yesterday afternoon 50 representative citizens of San Francisco met the Mayor, the Chief of Police and the General Military authorities in the police office in the basement of the Hall of Justice. ...

Continued on Page Two

With their offices destroyed by fire, three major San Francisco newspapers—*The Call, The Chronicle,* and *The Examiner*—joined forces to put this first issue out, using the presses of *The Oakland Tribune*. The paper was passed out free of charge on April 19th, the day after the earthquake.

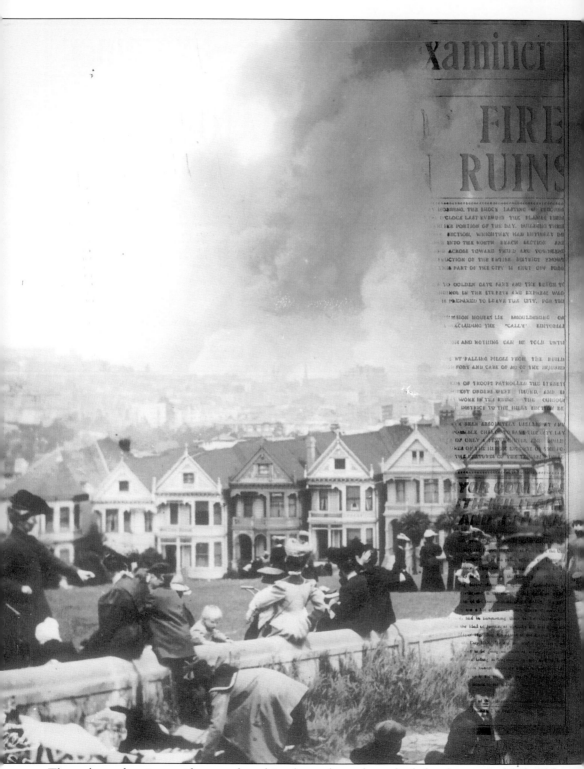

Throughout the city, residents gathered in the parks and watched the devastating fire. This photo, taken in Alamo Square at Hayes and Steiner Streets, shows the famous row of "Victorian

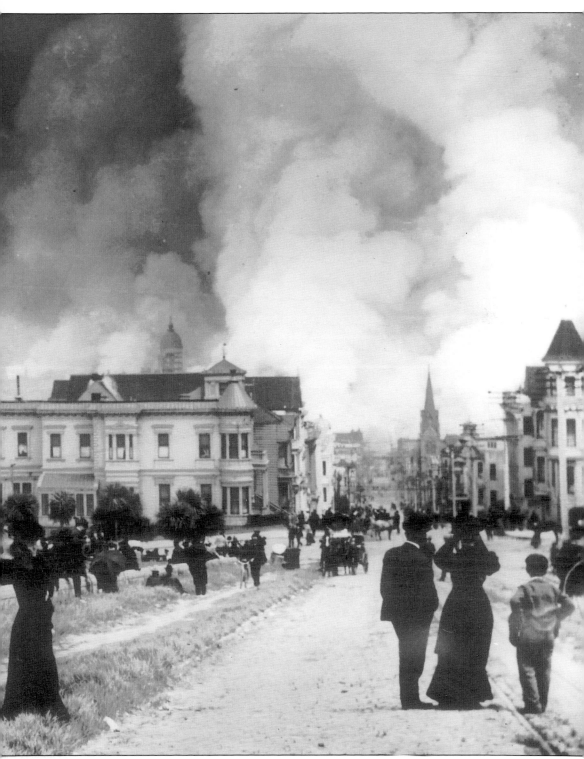

Ladies" that would survive to become one of the most famous postcard images of the city nearly a century later.

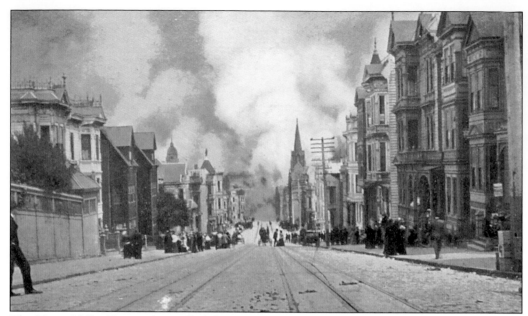

The Hayes Valley Fire is often called the "Ham and Eggs Fire" because as the story goes, the fire was started by a woman cooking ham and eggs in her kitchen.

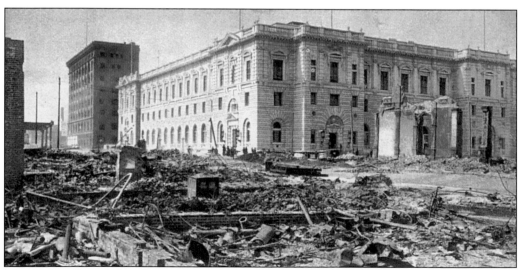

The $2.5 million Italian Renaissance Post Office was not open a year when the earthquake struck. The building, on a piling foundation, withstood the earthquake. However, the sidewalk and street, built over the bed of a former stream, sank several feet.

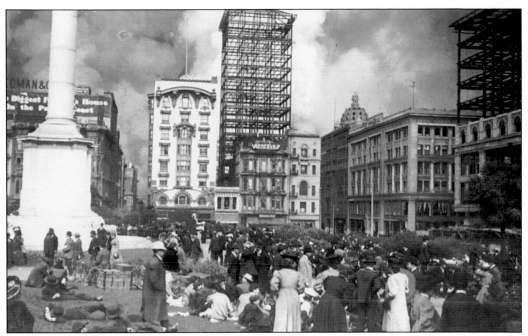

Union Square provided a temporary safe haven for residents in the early afternoon of April 18th. Some watched, others rested as the fires burned south of Third and Market Streets.

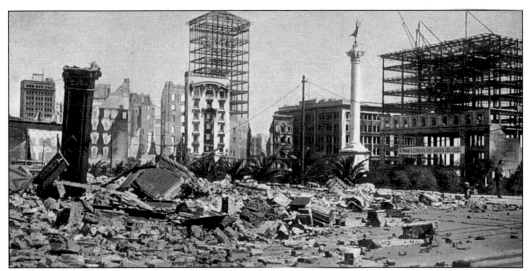

By the next morning, the flames had passed through Union Square, leaving total destruction in its wake. "Victory" survived at her perch atop the Dewey Memorial.

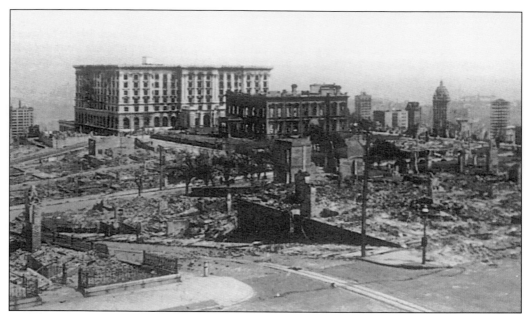

In the wake of the fire, every wooden building on Nob Hill was burned to the ground. Although the interiors were gutted by the flames, the solid walls of the Fairmont Hotel and the brownstone mansion of James Flood remained intact.

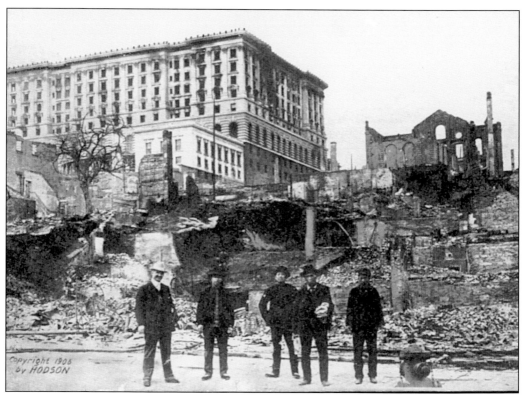

As the smoke cleared, refugees were overcome with emotion when they saw the steadfast form of the Fairmont Hotel still standing majestically amidst all the destruction.

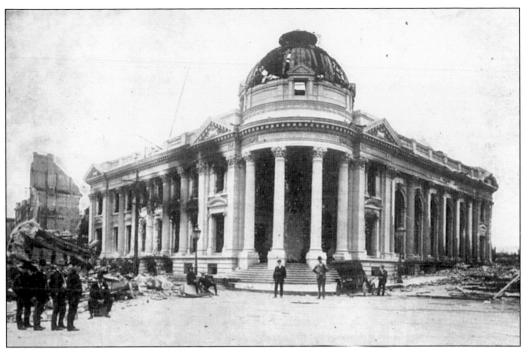

The Hibernia Bank, located at One Jones Street, proved to be another marble tower of strength. At the time of its construction in 1892, the building was declared "the most beautiful building in the city."

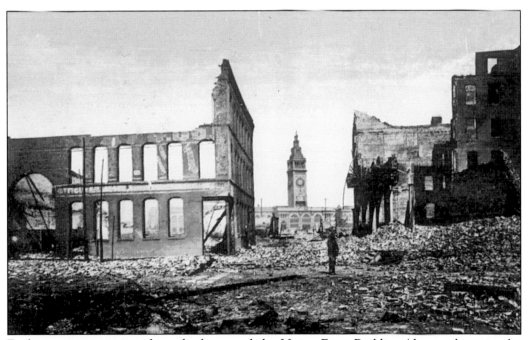

Fireboats pumping water from the bay saved the Union Ferry Building (shown above in the distance) from sharing the fate of the neighboring buildings.

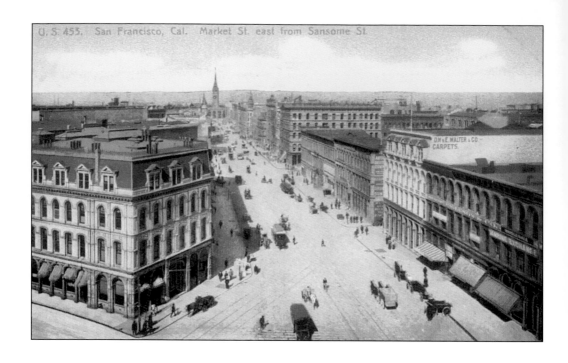

When it was over, estimated death tolls ranged from 700 at the time to today's recalculation of 3,000. These dramatic before and after images of Market Street, looking east towards the surviving Ferry Building, demonstrate both the catastrophic effect of the disaster and the resiliency of the San Francisco people. By the time the bottom photo was taken, the electric streetcars were already back in operation. Residents had begun to rebuild their beloved city.

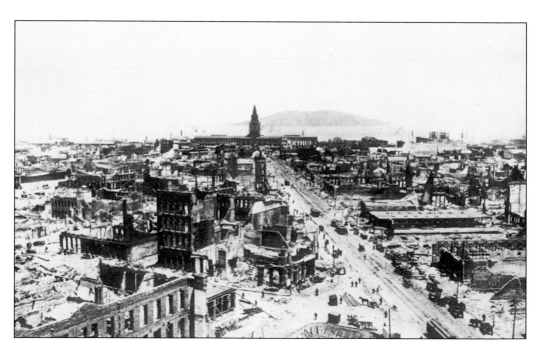

Five

A PHOENIX RISES
FROM THE ASHES

The great calamity . . . left no one with the impression that it amounted to an irrecoverable loss. This afternoon everyone is talking about it but no one is in the slightest downcast. . . . Nowhere is there any doubt but that San Francisco will rise again, bigger, better and after the very briefest of intervals.

—H. G. Wells

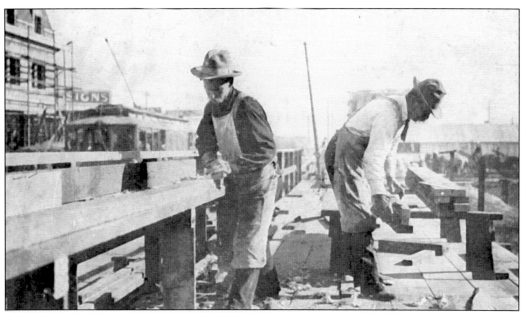

Wearing badges saying "Let's rebuild at once!" the citizens immediately began to rebuild their lives and their city. By the summer of 1907, 6,000 buildings had been completed and 3,000 more were being built.

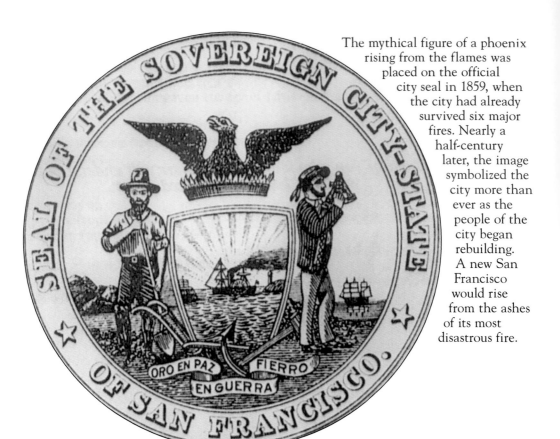

The mythical figure of a phoenix rising from the flames was placed on the official city seal in 1859, when the city had already survived six major fires. Nearly a half-century later, the image symbolized the city more than ever as the people of the city began rebuilding. A new San Francisco would rise from the ashes of its most disastrous fire.

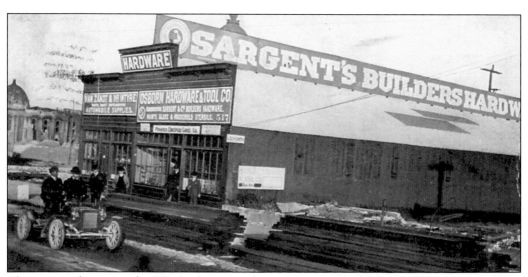

This postcard, sent to the J.E. Andrews Hardware Store in Poughkeepsie, New York, in 1906, proudly shows the first hardware store erected in the city after the earthquake.

Fillmore Street suffered less damage and quickly became an active business district in the days following the fire. The cable cars returned to the busy street by April 21. This view, looking south from O'Farrell Street, shows the scurry of activity and makeshift signs indicating newly relocated shops.

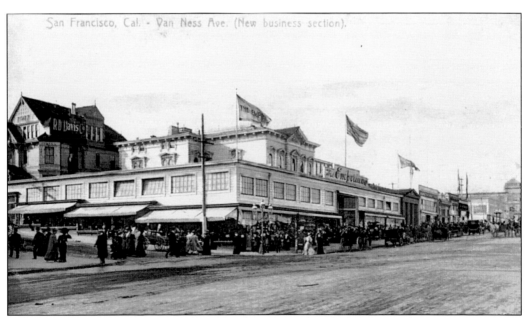

Fillmore Street's prominence was short lived. It wasn't long before major downtown businesses moved to Van Ness Avenue, making it the new retail center. The temporary location of the Emporium Department store can be seen in the center of this 1906 postcard of Van Ness Avenue, looking north from Geary Street.

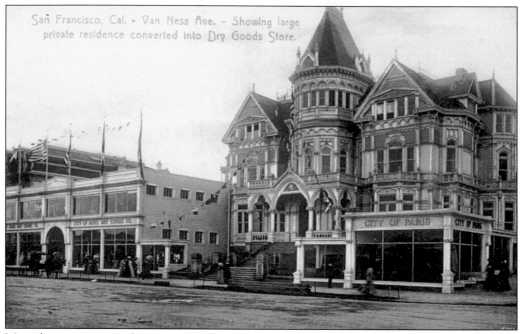

Many large private residences on Van Ness Avenue were converted for business use, such as the one that housed the popular City of Paris store shown above.

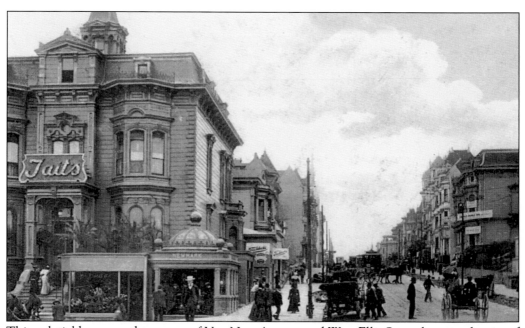

This palatial home on the corner of Van Ness Avenue and West Ellis Street became the site of Taits restaurant, one of the city's favorite dining establishments.

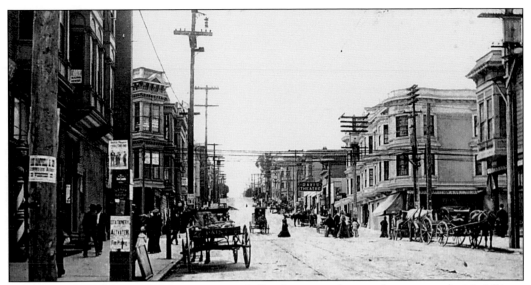

A large number of the city's streets are named after famous and not-so-famous people. McAllister Street, shown above, was named for Hall McAllister, a prominent prosecutor in the 1850s. This photograph of McAllister Street looking west at Fillmore shows the Davis Theater. Fillmore Street is named after U.S. President Millard Fillmore.

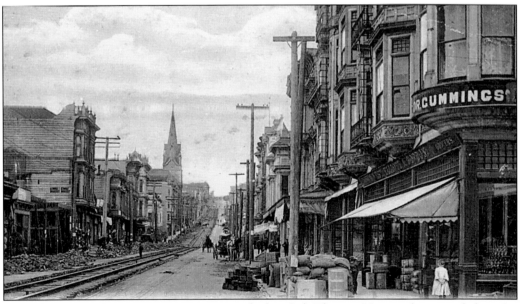

In another example, Hayes Street was named after Col. Thomas Hayes, who owned the 160-acre parcel west of City Hall now known as Hayes Valley. This photograph shows Hayes Street looking west from Octavia Street, which incidentally was named after Octavia Gough. Gough Street, named after her brother Charles Gough, is one block over.

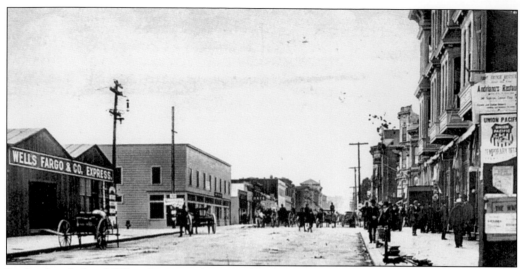

In the days before UPS pickups, residents could take their packages to a Wells Fargo office, such as the one shown in this photograph of Golden Gate Avenue near Franklin Street.

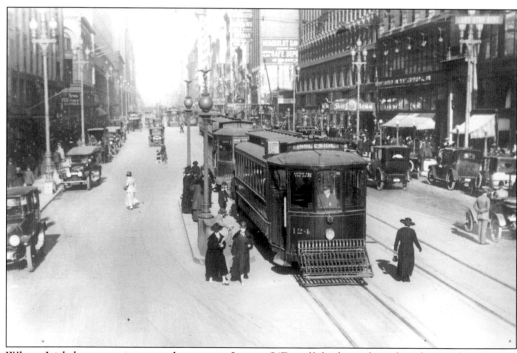

When Irish-born engineer and surveyor Jasper O'Farrell laid out his plan for Market Street, the 120-foot width, (twice that of most other city streets) was met with fierce controversy. As apparent in this c. 1912 photograph, the extra width turned out to be extremely beneficial.

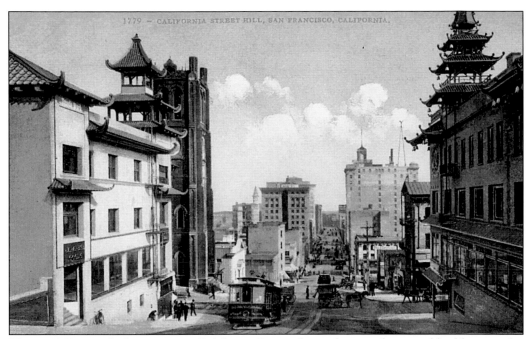

This c. 1910 view, looking east on California Street, shows the pagoda-capped buildings at the intersection with Grant Avenue. Old St. Mary's Church can be seen on the left.

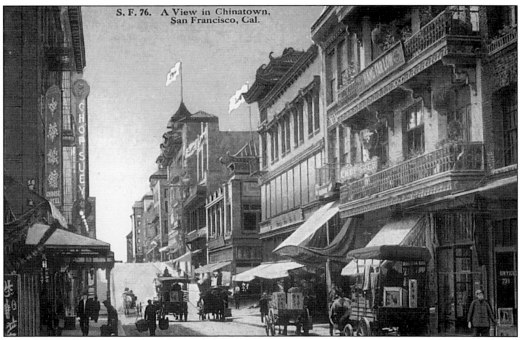

After the disastrous earthquake and fire, Chinatown was rebuilt under strict building codes that required the use of brick or concrete. Soon, the addition of pagoda style roofs, decorative cornices, and varying degrees of chinoiserie began to be seen, creating the "San Francisco Chinese" architecture that is so appreciated today.

Life seemed to be back to normal as residents enjoyed this beautiful day in Union Square. The totally renovated Hotel St. Francis had added a third wing in 1908, making it the largest hotel on the West Coast at that time.

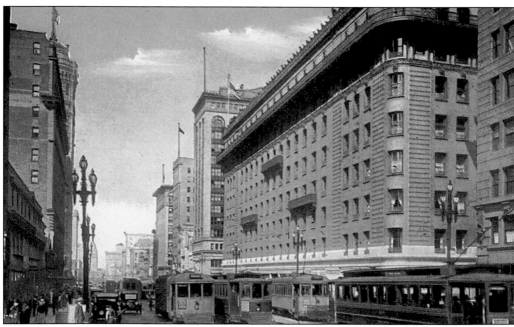

Shown in this *c.* 1910 postcard, the Palace Hotel, gutted by the 1906 Fire, had been rebuilt and was again open for business. The luxurious hotel quickly became the focal point of San Francisco social life.

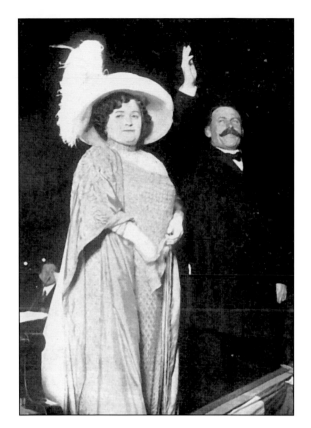

Mayor P.H. McCarthy introduces opera star Luisa Tetrazzini to the crowds on Christmas Eve, 1910. In celebration of the city's recovery, the world-renowned opera star performed on a stage set up in front of the Chronicle Building at Lotta's Fountain, where a plaque commemorates the event today. Shown below, a crowd of over 100,000 gathered in the streets to witness the historic event.

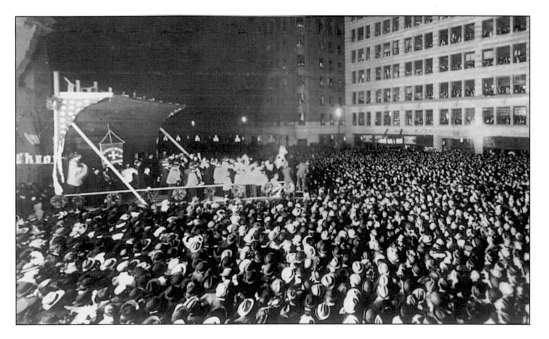

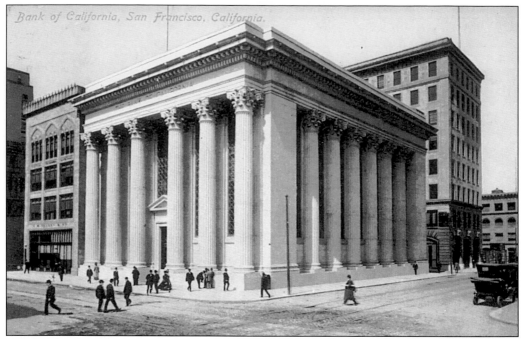

The Bank of California was founded in 1864 by William Ralston and Darius Mills. In 1908, this new headquarters was erected at 400 California Street (the site of the original bank) and was modeled after the Knickerbocker Trust Company in New York City. In 1968, the building was declared a City Landmark.

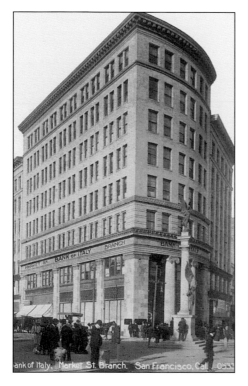

A.P. Giannini established his Bank of Italy in 1904 and focused on helping small businesses and farmers. During the fire of 1906, he saved the banks assets by hiding them under vegetables in a wagon and transporting them to safety as the fire approached. The Bank of Italy was the first bank to reopen after the disaster. This 1912 photo shows the Market Street branch. Giannini formed the Bank of America in the 1930s and by 1948 it was the largest bank in the country.

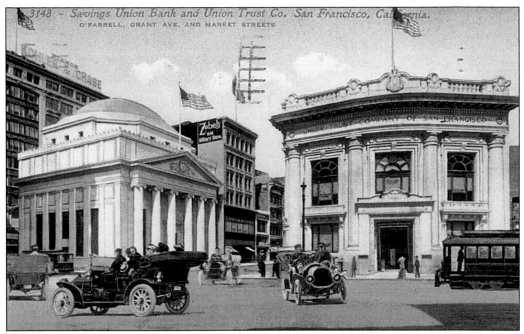

As San Francisco became the financial center of the west, the number of banks in the city proliferated. This 1915 postcard shows two examples—the Savings Union Bank and the Union Trust Company—at the junction of O'Farrell, Grant Avenue, and Market Streets.

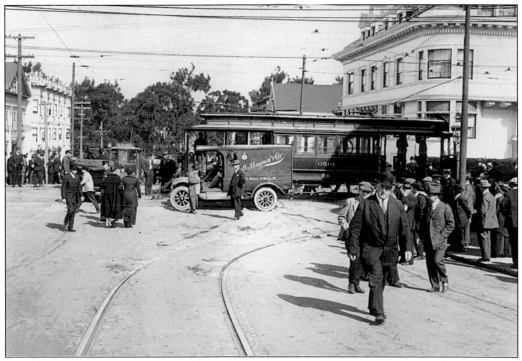

This October 6, 1914, photograph was taken at Masonic Avenue and Page Street. An I. Magnin company truck and an electric streetcar are shown stopping for pedestrians at the busy intersection.

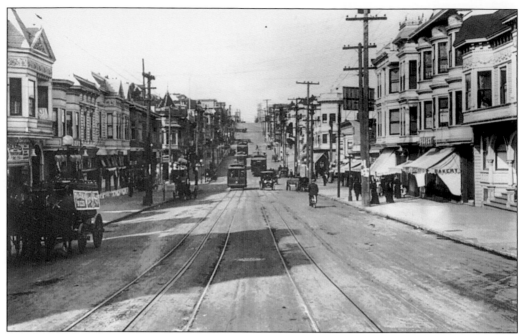

Rows of Victorian homes create a magical view of Castro Street in this November 1914 photograph. The photograph was taken at 4623 Castro Street, looking north between Eighteenth and Nineteenth Streets.

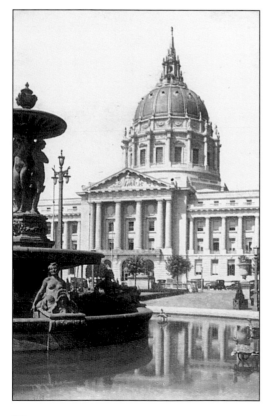

The new City Hall, the focal point of San Francisco's new Civic Center, was built in 1915. Designed by John Bakewell Jr. and Arthur Brown Jr., the stunning structure has a huge dome modeled after St. Peter's Basilica in Rome. The dome rises 308 feet above the street, making it higher than the Capitol dome in Washington D.C. The Civic Center complex was begun in 1912 and is considered by many to be the finest Beaux Arts architecture in the country.

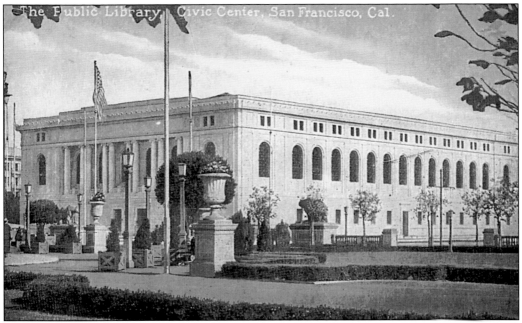

The Main Public Library, situated across the plaza from City Hall, was completed in 1917. The one million dollar structure reflects the Beaux Arts Style of City Hall. In April 1996 a new Main Library, which houses the San Francisco History Center, was built at 100 Larkin Street.

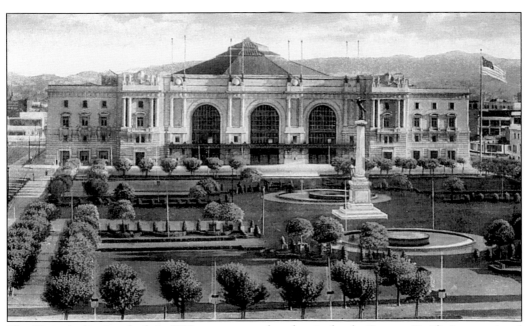

The Civic Auditorium built in 1913 was presented to the city by the Panama-Pacific International Exposition Committee. The auditorium was the site of the 1920 Democratic National Convention at which James M. Cox was nominated as the Democratic Presidential Candidate, with Franklin D. Roosevelt as his Vice-Presidential running mate. Mr. Cox lost the presidential election to Warren Harding, who subsequently died of a stroke at the Palace Hotel in 1923.

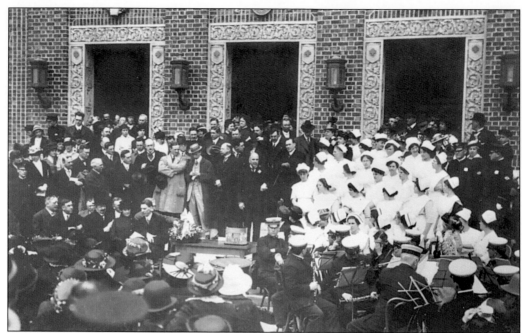

It was a festive occasion, complete with a band, when San Francisco Mayor "Sunny" Jim Rolph addressed the crowd at the May 1, 1915 dedication of the San Francisco General Hospital. Mayor Rolph was the Mayor of San Francisco for 19 years, a record unmatched before or since.

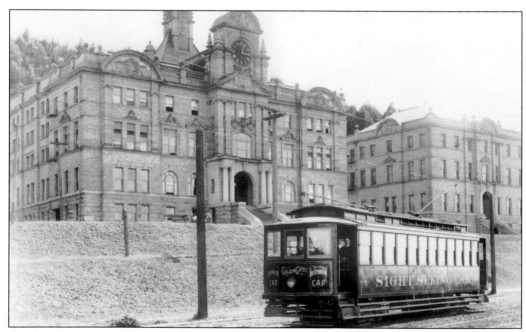

An electric streetcar carrying sightseers passes the Medical Center of the University of California at Parnassus and Third Avenues in this 1908 photo. The center (formerly known as the Affiliated Colleges) dates from 1862, when Dr. H.H. Toland founded the Toland Medical School, the city's first professional school. Adolph Sutro donated the above site in 1895 for new facilities. In 1902, the University of California took over the properties and support of the medical school.

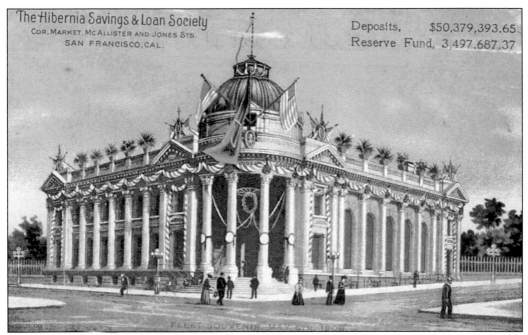

By the time this postcard was produced as a May 6, 1908, souvenir, Hibernia Savings and Loan Society was completely renovated and proudly boasted deposits of $50,379,393.65 and a reserve fund of $3,497,687.37

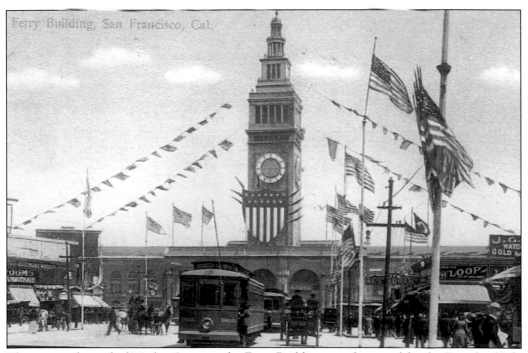

The area at the end of Market Street at the Ferry Building was decorated for the Fourth of July at the time of this 1912 postcard.

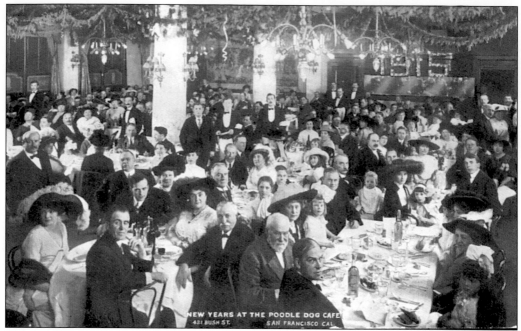

The Poodle Dog Café at 421 Bush Street was the site of this 1913 New Year's Eve party. It was a festive occasion as residents planned to show their new city to the world. From 1912 on, the date "1915" was flashed throughout the city (as shown in this photo) in anticipation of the upcoming 1915 Panama-Pacific International Exposition.

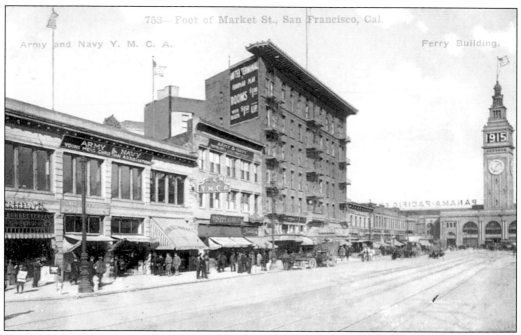

The 1915 date and sign advertising the Exposition on the Ferry Building can be seen in this view of Market Street. The Army and Navy YMCA stands on the left as well as the Terminal Hotel, which offers rooms for $1 (with bath $1.50).

Six

A TIME FOR
CELEBRATION

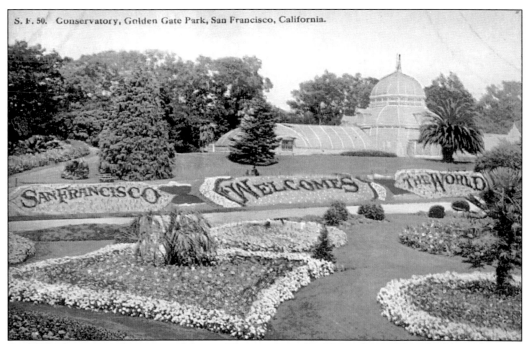

S. F. 50. Conservatory, Golden Gate Park, San Francisco, California.

SAN FRANCISCO WELCOMES THE WORLD

By 1915, there was plenty to celebrate. The residents had been feverishly rebuilding for nine years and the results were nothing short of amazing. To celebrate its triumphant recovery and the opening of the Panama Canal, the city hosted the Panama Pacific International Exposition and welcomed the world. This postcard of the Conservatory of Flowers in Golden Gate Park echoed the enthusiastic invitation. The 15,000-square foot Conservatory is modeled after the Palm House in London's Kew Gardens and is the oldest building in Golden Gate Park.

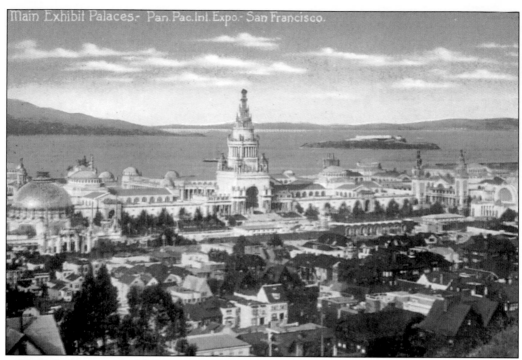

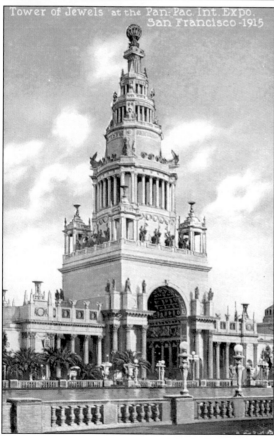

Tower of Jewels at the Pan-Pac.Int.Expo.
San Francisco -1915

The long-awaited Panama-Pacific International Exposition opened on February 20, 1915, with 29 U.S. states and 25 foreign countries participating. The Tower of Jewels, shown to the left, was decorated with more than 100,000 shimmering colored-glass jewels. The 43-story tower became the fair's symbol and could be seen from throughout the Bay area.

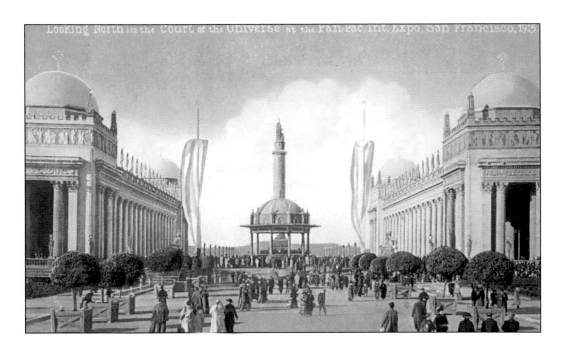

Looking North in the Court of the Universe at the Pan-Pac. Int. Expo. San Francisco, 1915.

In addition to the many states and foreign country pavilions, 11 splendid exhibition halls were constructed, each designed to illustrate a particular architectural style.

By the time the fair ended on December 4, 1915, nearly 20 million visitors had attended the magical event. The Yacht Harbor and the Marina (shown below) still exist today.

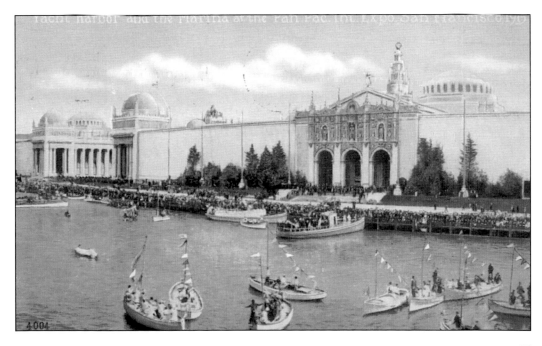

Yacht Harbor and the Marina at the Pan-Pac. Int. Expo. San Francisco, 1915

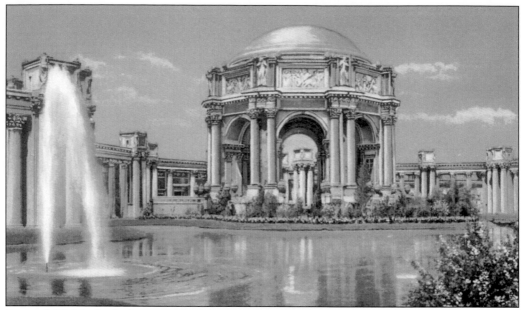

Bernard H. Maybeck designed the Palace of Fine Arts, which displayed a collection of 11,400 paintings and sculptures at the 1915 Exposition. It so captivated San Franciscans however, that it was not bulldozed when the fair ended. Intended as a temporary structure, the building gradually deteriorated until 1959, when financier Walter Johnson donated $2.25 million towards the complete renovation of the Palace. Today it is home to the Exploratorium, a fascinating hands-on museum called "the best science museum in the world" by *Scientific American* magazine.

Much of the Marina District is built on land reclaimed after the 1915 Exposition. This 1919 photo, taken from Lyon Street, shows the only remaining fair structure, the Palace of Fine Arts, in the distant center and the cleared exposition site to the right.

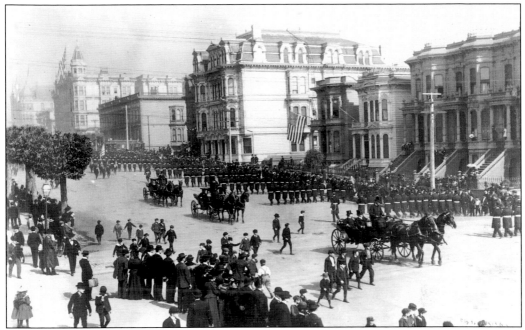

Grand parades have been a tradition for a long time as witnessed in this turn-of-the-century procession on Van Ness Avenue. The avenue was one of the city's most elegant thoroughfares, lined with Victorian mansions. Most of the spacious homes were lost when Van Ness was designated as a fire break during the Great Fire, requiring that the buildings be dynamited.

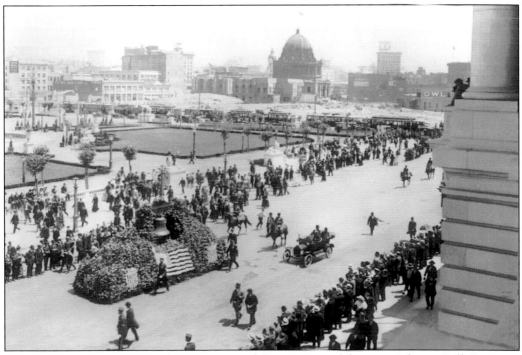

As part of the Panama-Pacific International Exposition celebration, Liberty Bell Day was celebrated with a parade through the new Civic Center on November 10, 1915.

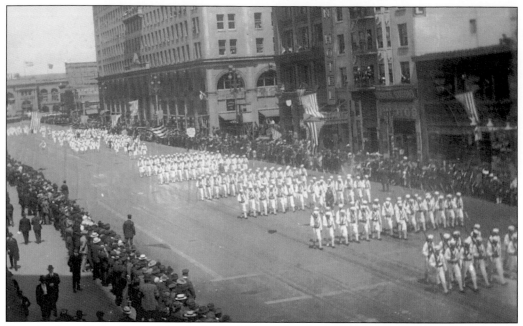

Recruits from Yerba Buena Island observed Navy Day by marching in this downtown parade on April 20, 1919.

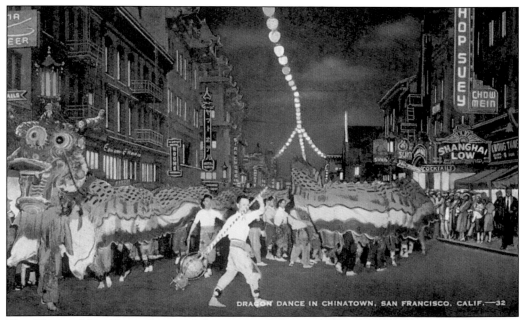

DRAGON DANCE IN CHINATOWN, SAN FRANCISCO, CALIF.—32

The Chinese New Year is honored during a week-long celebration of family parties, fireworks, and numerous pageants. The Grand Finale is a spectacular parade which features the 150-foot long "Living Dragon," which has 50 or more people inside the enormous costume.

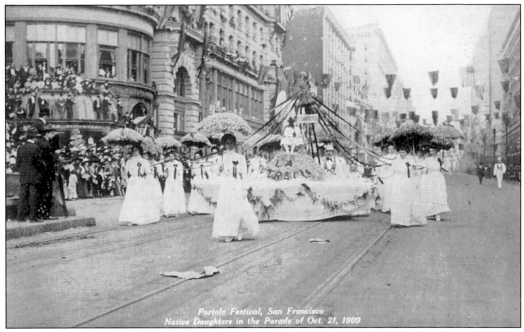

Portola Festival, San Francisco
Native Daughters in the Parade of Oct. 21, 1909

The popularity of the Portola Festival Parade was evident as crowds jammed the sidewalks, stood on rooftops, and leaned out windows to watch the elaborate October 21, 1909 celebration. The Native Daughters and their impressive float approach the photographer.

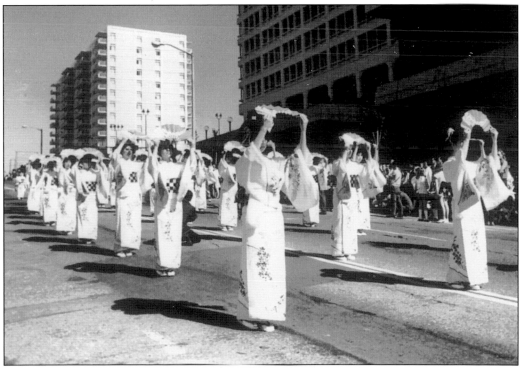

Every April, the Cherry Blossom Festival is celebrated with many festivities and a special parade in Japantown.

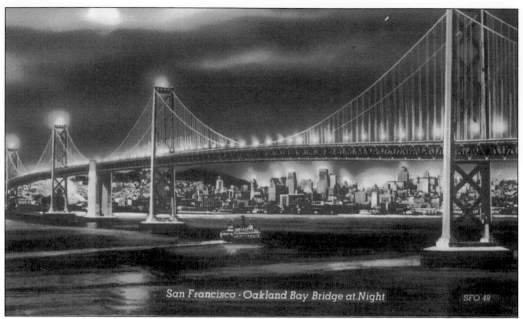

San Francisco - Oakland Bay Bridge at Night SFO 48

Two of the most distinguishing features of San Francisco are the San Francisco-Oakland Bay Bridge (above) and the Golden Gate Bridge. Both built in the 1930s, they transformed life around the Bay Area and made the city easily identifiable all over the world.

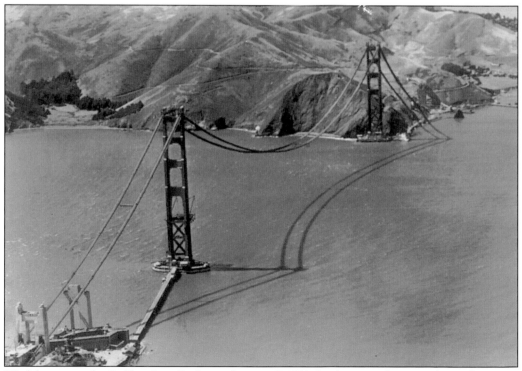

Work began on the Golden Gate Bridge on January 5, 1933. By the time of its completion four years later, over 100,000 tons of steel and 80,000 miles of cable wire would be used in its construction. The towers, shown in this mid-construction photo, stand 746 feet above water.

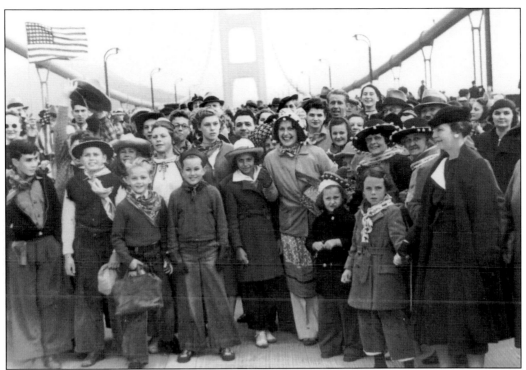

The enthusiasm and pride radiates from the faces of the citizens as they inaugurate the Golden Gate Bridge on "Pedestrian Day"—May 27, 1937. Local schools and businesses were closed for the special occasion so residents could attend the 6 a.m. opening. Approximately 200,000 people crossed the bridge for a 5¢ fee. The bridge opened for automobile traffic the following day.

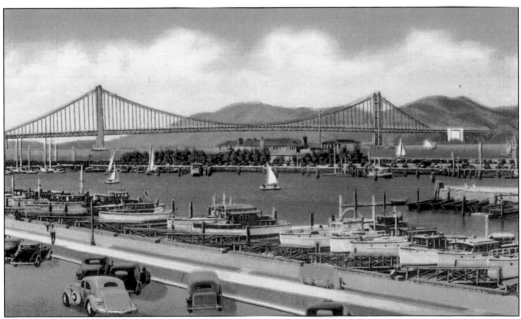

From its 1937 opening to the present day, the view of the Golden Gate Bridge from Yacht Harbor, shown in this 1937 postcard, has captured the hearts of spellbound observers.

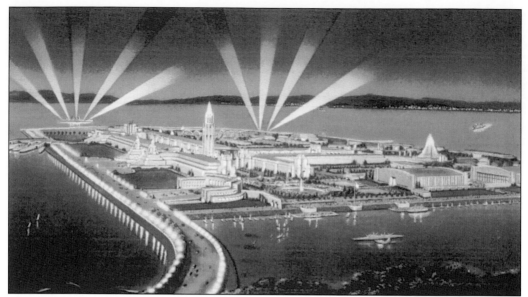

The Golden Gate International Exposition of 1939–1940 was the city's third World's Fair. It celebrated the Trans-Pacific China Clipper airplane service (1935), the San Francisco-Oakland Bay Bridge (1936) and the Golden Gate Bridge (1937). Thirteen states and 37 countries took part in the fair, which opened on February 18, 1939, and was attended by over 17 million visitors. In this illuminated night view, the 400-foot high "Spire to the Sun" dominates Treasure Island, the site of the fair. A China Clipper seaplane is shown in the bottom right corner.

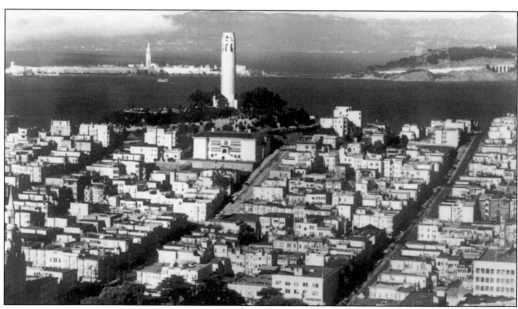

This 1939 aerial photo provides a splendid view of Coit Tower atop Telegraph Hill. The 210-foot tower, built in 1933 as a monument to the city's firefighters, was a gift from Lillie Hitchcock Coit. Coit's lifelong admiration and support of the firefighters resulted in her being chosen an honorary member of the Knickerbocker Hose Company No. 5, whose badge she wore proudly. The 1939 World's Fair can be seen on Treasure Island in the distance. The island became a United States Naval Base when the country entered World War II.

Seven

PEOPLE AND PLACES

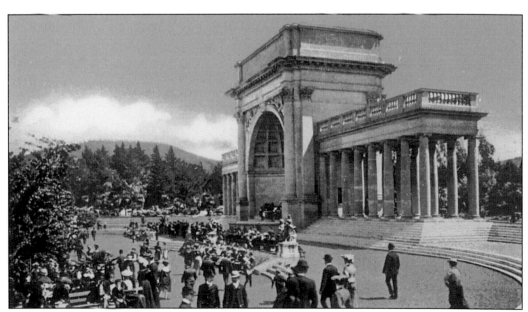

The Sunday afternoon band concerts held at the Music Pavilion in Golden Gate Park became a San Francisco tradition. This 1902 postcard shows the Italian Renaissance Music Pavilion, which was built in 1900 as a gift to the city from Claus Spreckels.

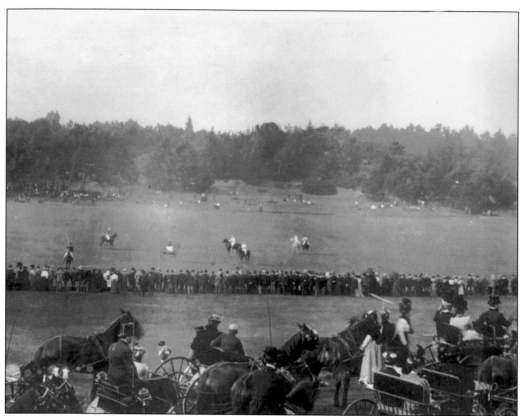

A polo tournament draws a large crowd of spectators in Golden Gate Park. In 1911, President William Howard Taft broke ground at the field for the upcoming Panama-Pacific Exposition to be held there, but public outcry to protect the park resulted in the change of location to the newly created land in the Marina District.

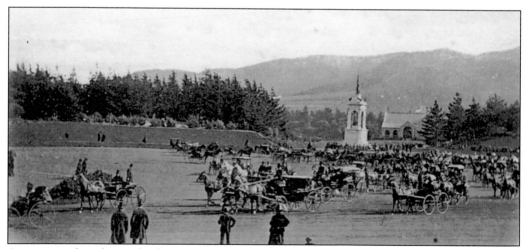

As witnessed in this early photograph, the open green around the Francis Scott Key Memorial offered ample space for Saturday afternoon carriage rides. The monument was erected in 1887 with a $60,000 bequest of philanthropist James Lick.

Parks were a large part of life in the city, as evidenced by this scene of mothers taking their children to Golden Gate Park for pony rides.

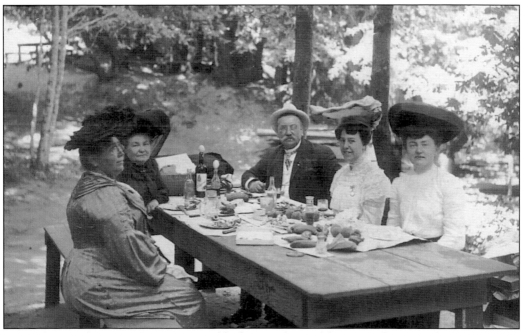

As it does today, San Francisco's mild climate, beautiful surroundings, and opportunities attracted families from many nations. Members of the Kuhl family, who emigrated from Germany, enjoy an afternoon picnic in Golden Gate Park.

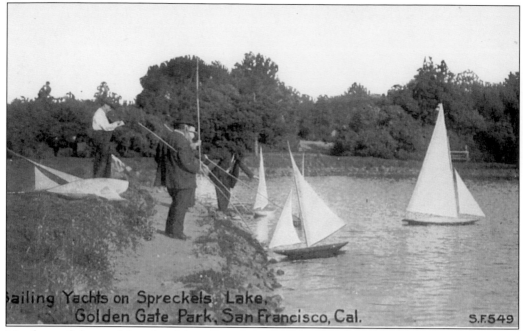

Sailing Yachts on Spreckels Lake,
Golden Gate Park, San Francisco, Cal.
S.F.549

Members of the model yacht club at Spreckels Lake use bamboo wands to guide their yachts in this 1908 photograph. Spreckels Lake and its yacht club were created in 1900—starting a tradition still carried on by the San Francisco Model Yacht Club today.

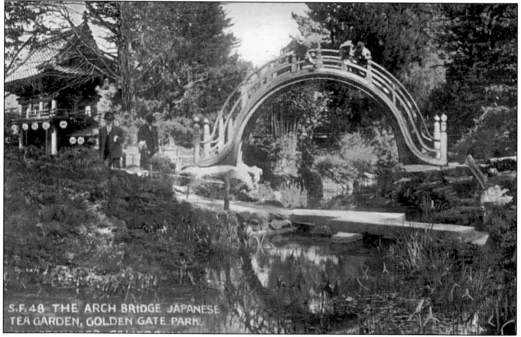

S.F.48 THE ARCH BRIDGE JAPANESE
TEA GARDEN, GOLDEN GATE PARK.

The Japanese Tea Garden, built for the 1894 California Midwinter Fair, is the oldest Japanese Garden in the country. This 1908 scene shows the Moon Bridge, an arched bridge, which, along with its reflection, forms a perfect circle. Many visitors have made wishes from the bridge— earning it the nickname of the Wishing Bridge.

96

The Pacific Sightseeing Company was one of the earliest tour providers in the city. With so many sites to see, visitors enjoyed the fact-filled bus tours with Bill Osgood, the tour guide who is pictured on this early brochure.

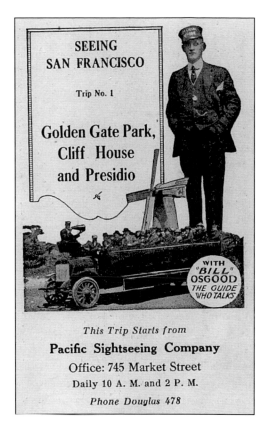

SEEING
SAN FRANCISCO

Trip No. 1

Golden Gate Park,
Cliff House
and Presidio

WITH "BILL" OSGOOD THE GUIDE WHO TALKS

This Trip Starts from
Pacific Sightseeing Company
Office: 745 Market Street
Daily 10 A. M. and 2 P. M.
Phone Douglas 478

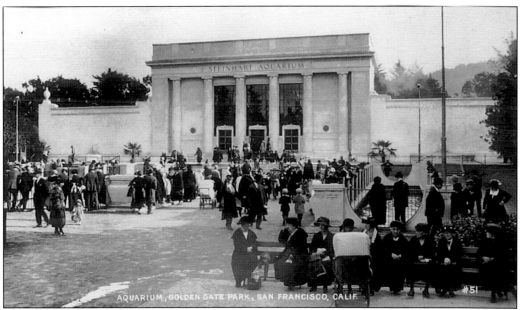

In this 1928 photo, crowds gather outside the Steinhart Aquarium, one of the popular attractions on the park tour. The Aquarium, founded in 1923, was the gift of Ignatz Steinhart. Today the 207 aquariums in the facility contain over 14,000 species, from reptiles to seabirds.

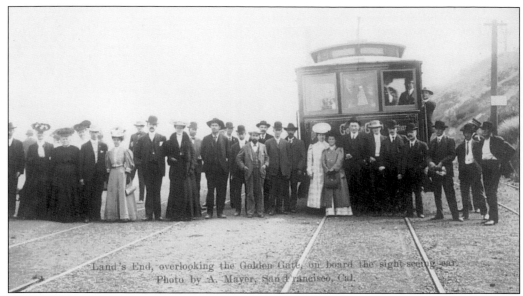

Land's End, overlooking the Golden Gate, on board the sight-seeing car.
Photo by A. Mayer, San Francisco, Cal.

Visitors arrived nearly a century ago to visit Land's End and the incomparable Golden Gate. Some things never change—with updated fashions and a current tour bus, this shot could be taken today.

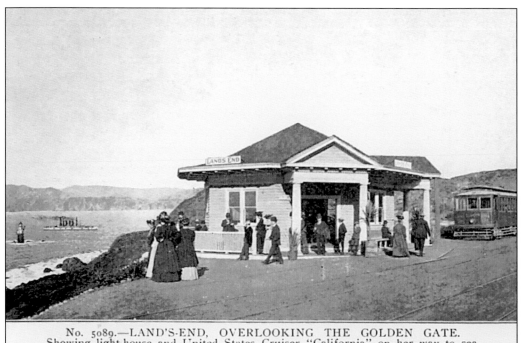

No. 5089.—LAND'S-END, OVERLOOKING THE GOLDEN GATE.
Showing light-house and United States Cruiser "California" on her way to sea.

Tourists take in the dramatic scenery from Lands End, overlooking the Golden Gate. Before returning to their sightseeing car, the visitors would probably have picked up some of the "new" postcards, an absolute "craze" created when Congress passed the law in 1898 providing a special 1¢ postage rate for the cards. Travelers immediately began collecting the images from their journeys for albums and to send home to loved ones.

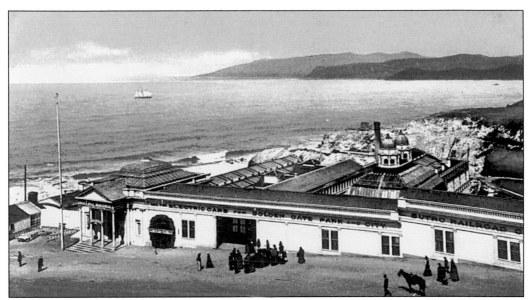

Former mayor and philanthropist Adolph Sutro built the Sutro Baths in 1896. The three-acre resort was located just north of his Cliff House restaurant.

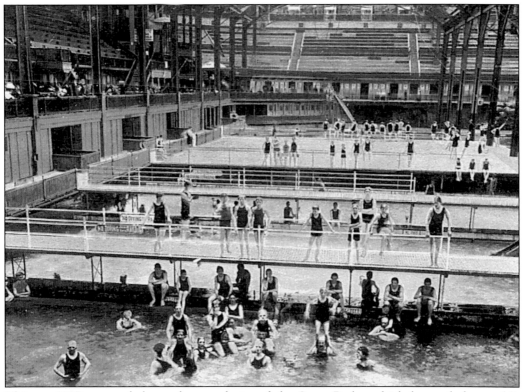

This pre-1907 postcard shows the popularity of the Sutro Baths, which boasted the world's largest indoor pools, numerous restaurants, and many activities. The resort closed in 1952 and was destroyed by a fire in 1966, but lives on in the memories of generations that spent many fun-filled hours there.

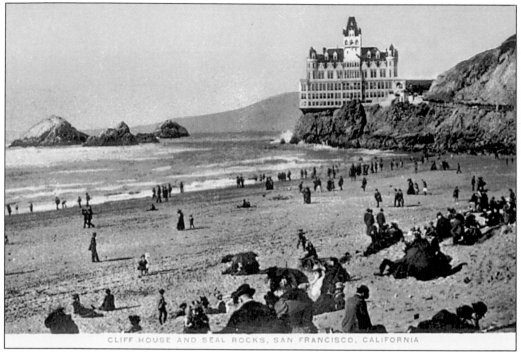

CLIFF HOUSE AND SEAL ROCKS, SAN FRANCISCO, CALIFORNIA

In 1905, the fresh ocean breeze, the wide stretch of beach, and the splendid view of the Cliff House and Seal Rocks made Ocean Beach the place to be on a free day.

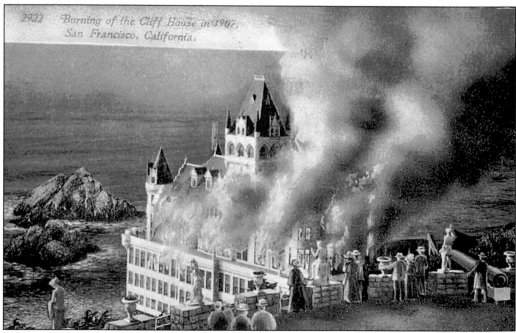

2922 Burning of the Cliff House in 1907, San Francisco, California.

After surviving the Great Earthquake and Fire of 1906, the stately Victorian Cliff House was itself destroyed by fire a year later. It was replaced in 1909 by the present Cliff House Restaurant.

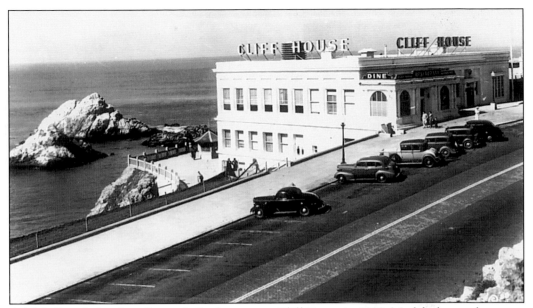

Adolph Sutro's daughter Emma built the present Cliff House in 1909. Modified over the years, the popular restaurant is now part of the Golden Gate National Recreation Area.

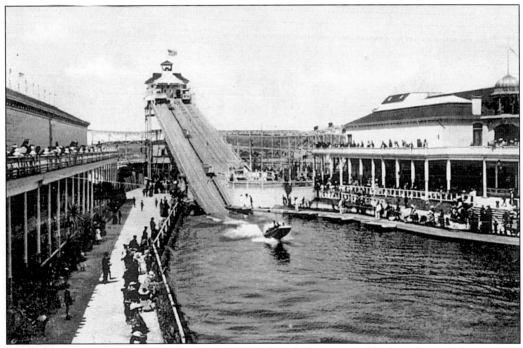

The Chutes resort and restaurant was located at Tenth Avenue and Fulton Street. The popular destination offered a variety of fun-filled activities and entertainment. Sophie Tucker performed there in 1911 while on the vaudeville circuit.

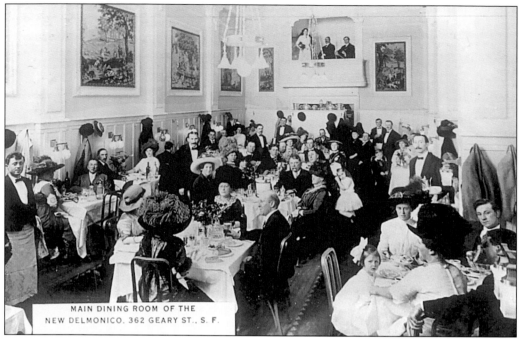

MAIN DINING ROOM OF THE
NEW DELMONICO, 362 GEARY ST., S. F.

Dining out was as popular in the early 1900s as it is today, nearly a century later. The main dining room of the new Delmonico Restaurant filled, with customers, is shown in this early photograph.

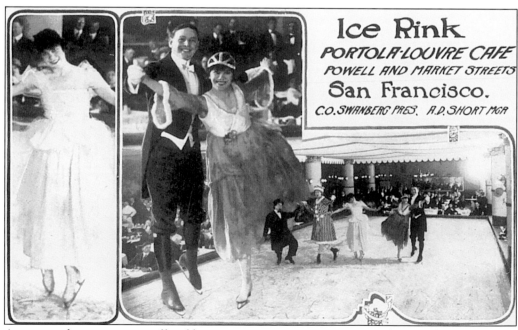

Ice Rink
PORTOLA-LOUVRE CAFE
POWELL AND MARKET STREETS
San Francisco.
C.O. SWANBERG PRES. A.D. SHORT MGR

A variety of activities were offered by enterprising restaurant owners. The Portola-Louvre Café, shown above, housed an ice-skating rink for its patrons.

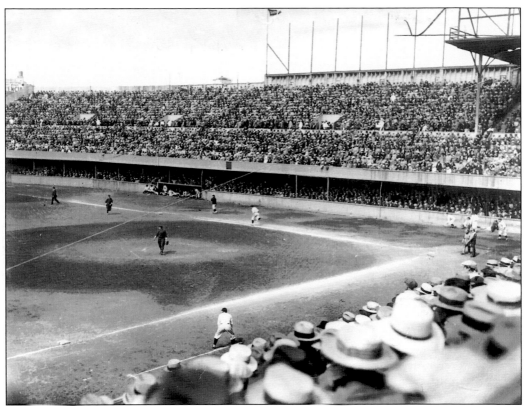

Before commercial airline travel became commonplace, major league baseball did not extend west of the Mississippi. Avid San Francisco baseball fans packed "Old Rec" recreation park to cheer the San Francisco Seals in this 1927 photo. Tickets for bleacher seats cost 50¢, grandstand seats were $1.25.

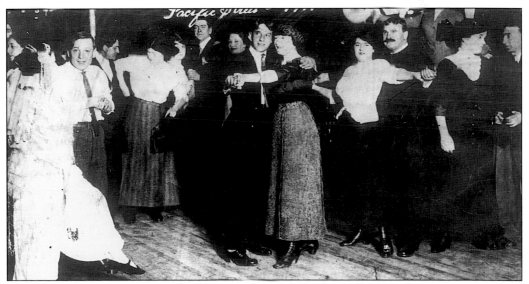

This 1912 photo captures the lively atmosphere of "Spider Kelly's" on Pacific Street, where couples enjoyed dance fads such as the Turkey Trot, the Bunny Hug, and the Grizzly Bear.

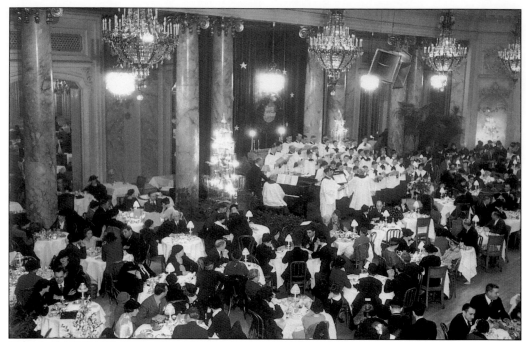

During the 1934 Christmas season, guests at the Palace Hotel were treated to a choral concert as they dined in the elegant hotel dining room.

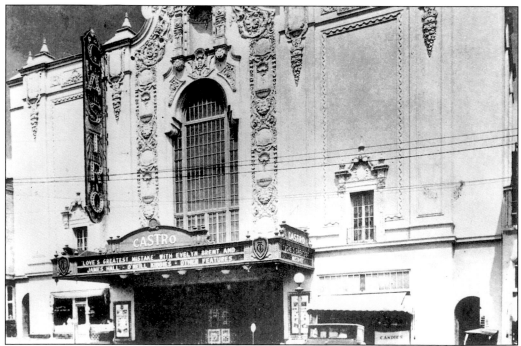

This 1927 photo shows the Castro Theater, considered by many the city's finest example of early 20th century movie palace architecture. The Spanish Renaissance Revival Theater, located at 429 Castro Street, was designed by Timothy Pflueger and opened in June 1922. In 1977, it was declared a San Francisco Historic Landmark.

Herbert L. Rothschild opened the California Theater on November 1, 1917. Located on the corner of Fourth and Market Streets, the luxury motion picture palace also held special Sunday concerts that featured a 55-piece orchestra. The weekly event was so well attended that it was continued for over a decade. The theater was renamed the "State Theater" in 1941, closed in 1954, and was demolished in 1960.

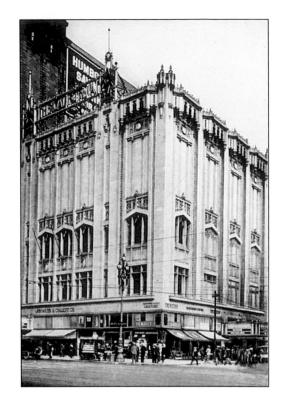

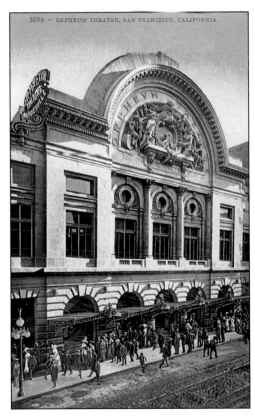

Vaudeville reigned at the Orpheum Theater, located on O'Farrell Street. After a visit to the theater, San Franciscans could also enjoy the famous Tait-Zinkand cabaret across the street.

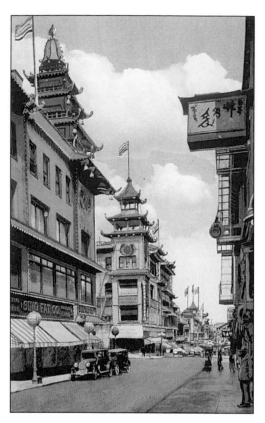

This view, looking north on Grant Avenue towards California Street, shows the Trade Mark Building on the corner (with flag extending from the pagoda-roof). The familiar Chinatown landmark, as well as the Pacific Telephone Exchange (page 107) were both built in 1909 and were the first buildings to display the architectural details that would soon distinguish Chinatown from the rest of the city.

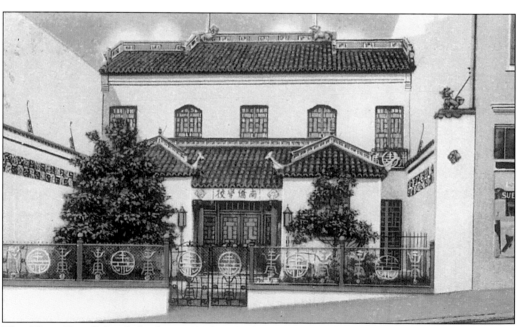

The Nam Kue School, built in 1925 at 765 Sacramento Street, is a fine example of the architectural embellishments that were added to structures in Chinatown, particularly in the 1920s.

The Pacific Telephone and Telegraph Company built this picturesque, pagoda-roofed telephone exchange to harmonize with the architecture in Chinatown. Completed in 1909, this telephone exchange and the Trademark Building were the first Chinese-style structures built in San Francisco. When the automatic telephone system took over, the exchange was no longer needed and closed in 1949. The building was then purchased by the Bank of Canton.

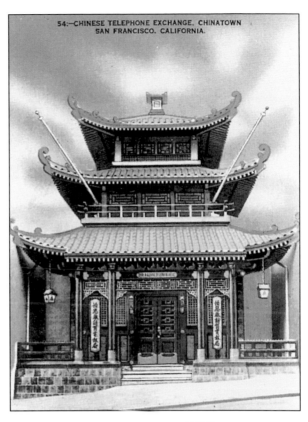

54:—CHINESE TELEPHONE EXCHANGE, CHINATOWN SAN FRANCISCO, CALIFORNIA.

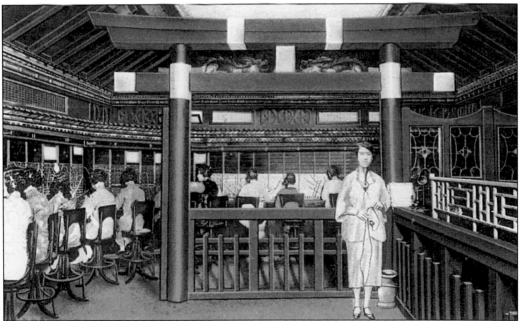

The position of telephone operator/receptionist at the Chinese Telephone Exchange was a prized one and was passed down from mother to daughter. The job required knowledge of English, five Chinese dialects, and the numbers of the 2,800 subscribers.

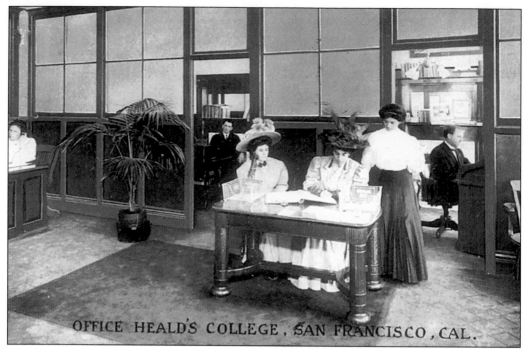

The future held great promise as young adults prepared themselves for a variety of careers. This postcard, sent to potential students in 1909 by Heald's Business College, announces the school's new location at 425 McAllister "near busy Van Ness Avenue."

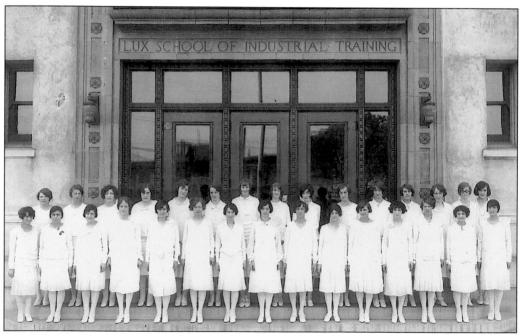

Miss Julia Austin (front row, seventh from the left) and her fellow 1927 graduates of the Lux School of Industrial Training look forward to new opportunities in the exciting city.

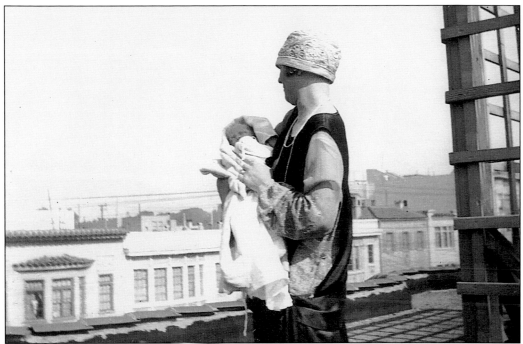

This 1924 photo celebrates more than one new beginning. Mrs. Edna Becker Detjen proudly holds her newborn son, Henry Louis Detjen Jr., one of the first generation born in the "new" Marina district. Mrs. Detjen is standing on a rooftop at Octavia and Francisco Streets overlooking some buildings that are being built by her husband.

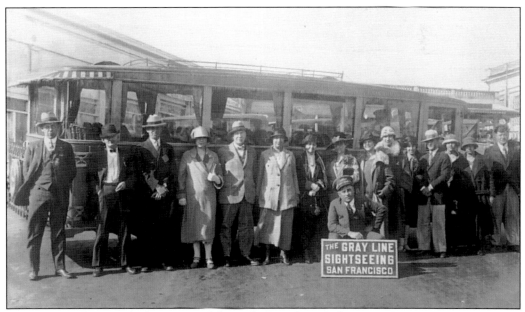

This c. 1925 photograph shows one of the early Gray Line Sightseeing Company tour groups as they prepare to enjoy all the sights the fascinating city has to offer.

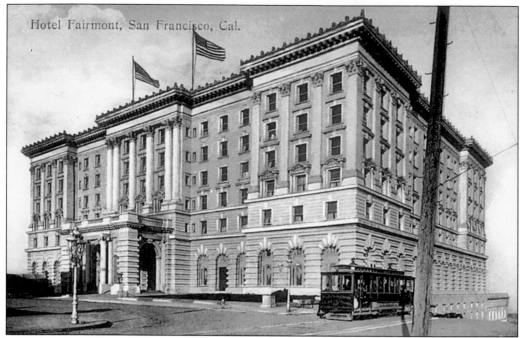

Hotel Fairmont, San Francisco, Cal.

The Fairmont Hotel is named for U.S. Senator and silver magnate James G. Fair, whose daughter Tessie Fair Oelrichs began building the grand hotel in 1902. As it neared completion, she sold it to Herbert and Hartland Law. On the eve of its opening, the hotel was gutted by the Great Fire of 1906. The exterior walls survived and the hotel was rebuilt inside by architect Julia Morgan, opening exactly one year to the day after the earthquake.

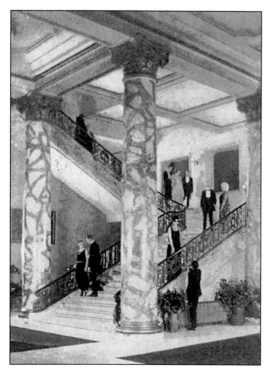

The Grand Staircase at the Fairmont is the site of a magical 1920s moment. The enormous lobby, with its massive columns, wraparound staircase, and vaulted ceilings provided such a dramatic setting that it was recreated on a Hollywood set for the television series "Hotel."

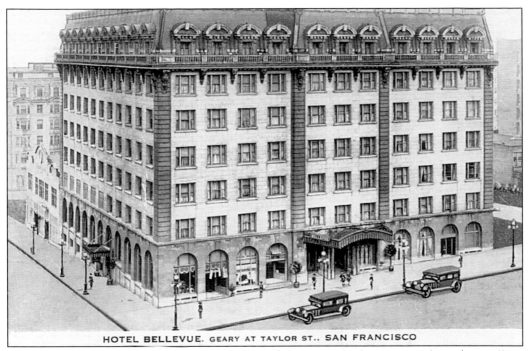

HOTEL BELLEVUE. GEARY AT TAYLOR ST., SAN FRANCISCO

The Hotel Bellevue, located at Geary and Taylor Streets, was built in 1910. After a $24 million renovation, this Beaux Arts hotel re-opened in 1995 as the Hotel Monaco.

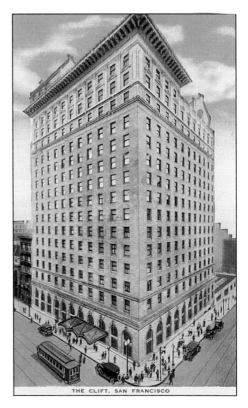

The Clift Hotel was built by lawyer Frederick Clift in 1915. In 1926, three additional stories were added which can be clearly seen in this postcard produced the same year. With its palatial Art Deco lobby and Redwood Room, it was and remains one of the city's prestigious hotels. The Redwood Room was completed in 1934. A single redwood tree (felled by lightning) provided the 22-foot columns and the wood paneling for the stunning room.

THE CLIFT, SAN FRANCISCO

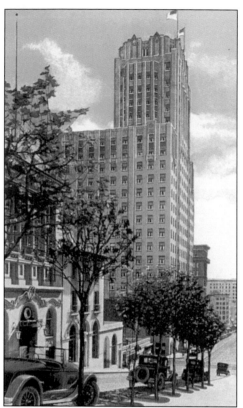

The vertical lines of the 22-story Sir Francis Drake Hotel, leading to a 6-story, set-back tower can clearly be seen in this postcard, which was produced shortly after the landmark hotel was completed in 1928. In keeping with the elegant atmosphere of the popular hotel, the doorman still wears a red Beefeater uniform patterned after guards uniforms at the Tower of London.

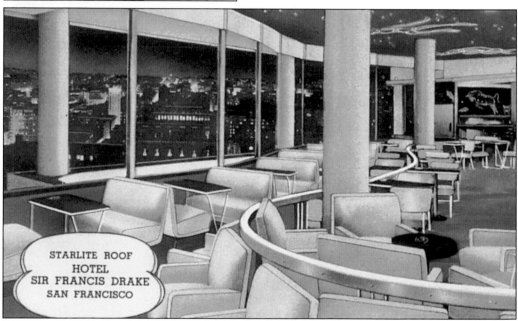

STARLITE ROOF
HOTEL
SIR FRANCIS DRAKE
SAN FRANCISCO

This 1940s postcard promoted the popular Starlite Roof . . . "high atop the Hotel Francis Drake. From panoramic windows . . . enjoy a breathtaking view by day or night." Today, the Harry Denton "Starlight Room" is one of the city's most popular destinations, offering cocktails, live jazz, dancing, and of course, the breathtaking view.

A building boom in the mid-1920s brought taller skyscrapers to the city. Many, like the Art Deco treasure 450 Sutter Street, with strong vertical lines, create the illusion of reaching to the sky. Built in 1929, it was the last structure built during the boom, which was ended by the Stock Market Crash that same year.

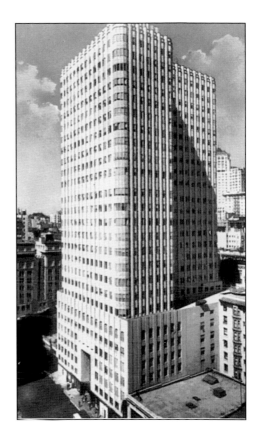

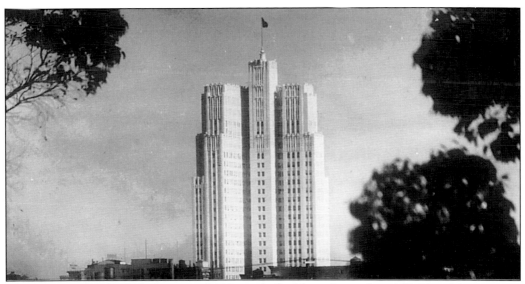

The 26-story Pacific Telephone and Telegraph Building, located at 140 New Montgomery Street, was the city's tallest skyscraper at the time of its completion in 1925. Architects for the impressive structure were Miller, Pflueger, and Cantin.

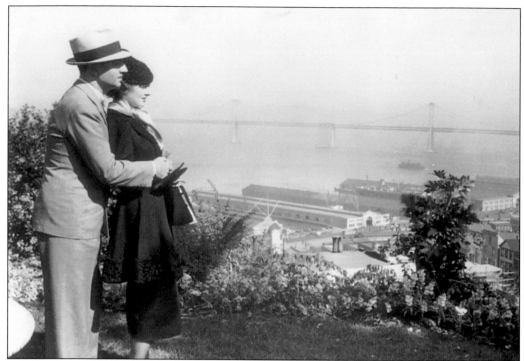

William Powell and Myrna Loy enjoy the view of the Bay Bridge from Telegraph Hill. The two movie actors were on a break between scenes while filming *After the Thin Man* for MGM in 1936.

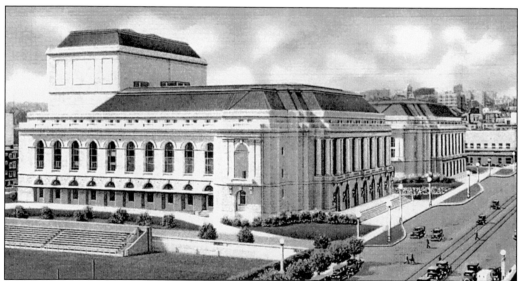

The War Memorial and Opera House, built in 1932, were among the last structures to be completed in the Civic Center. This postcard, produced the same year, shows the Opera House and its twin, the Veterans Memorial Building. In 1945, heads of state and delegates from 49 countries formed the United Nations at this site. The charter of the United Nations was drafted in the Veterans Building and signed at the Opera House. The formal peace treaty between the U.S. and Japan after World War II was signed in 1951 at the War Memorial-Opera House.

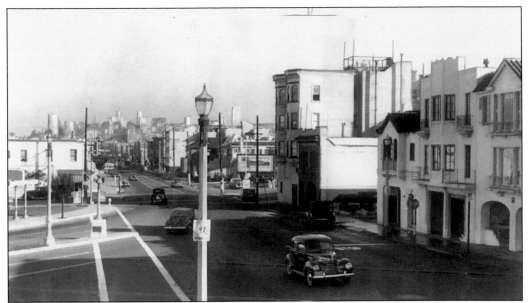

This December 12, 1940, photograph was taken before Lombard Street was widened to six lanes to accommodate the increased traffic of the Golden Gate Bridge. The age of automobile vacations had begun. In response, "motor courts" sprung up across the country, many offering guests the convenience of a private garage beneath their room. The first motor court built in the Marina district was the Marina Motel, which opened on Lombard Street in time for the 1939 World's Fair and is still run by the original family.

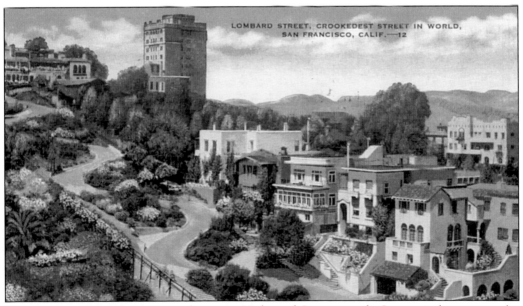

LOMBARD STREET, CROOKEDEST STREET IN WORLD, SAN FRANCISCO, CALIF.—12

The section of Lombard Street between Hyde and Leavenworth Streets is known as the "crookedest street in the world." The one-block stretch on Russian Hill with exhilarating Z-bends was originally straight, but the 27 percent incline was too difficult for cars to manage, so the curves were added in 1922.

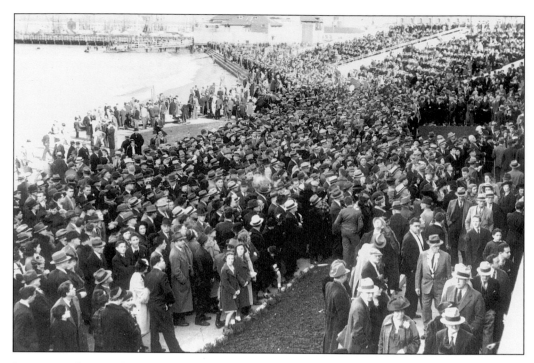

Large crowds attend the January 23, 1939, opening of Aquatic Park. The park casino (shown below) opened the same year and was built by the WPA—one of the programs launched by the Government to provide employment during the Great Depression. The Streamline Moderne casino is now home to the National Maritime Museum, which also maintains historical ships for visitors to board at the Hyde Street Pier.

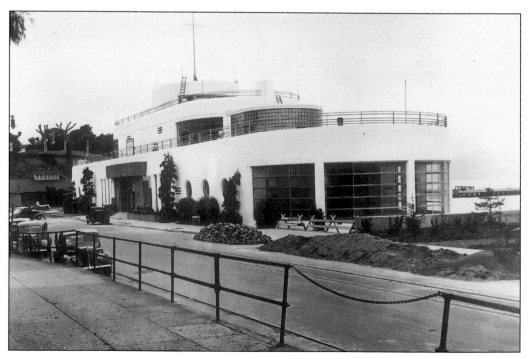

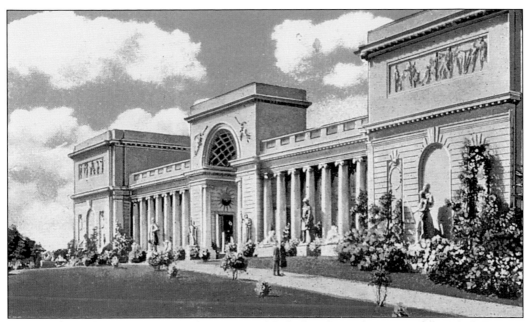

The California Palace of Legion of Honor, modeled after the 18th century Palais de la Legion d' Honneur in Paris, was a gift to the city from Alma de Bretteville Spreckels. The world-class art museum, dedicated to the memory of the 3,600 California men who lost their lives in France during World War I, opened on Armistice Day November 11, 1924.

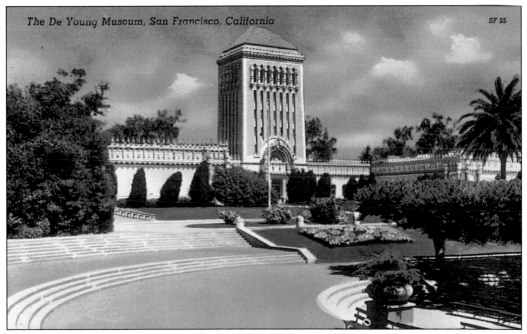

The M.H. de Young Museum opened during the California Mid-Winter International Exposition on March 25, 1895 in the fair's Fine Arts Building. The Museum moved in 1917 to the building shown above, which was built with funds donated by Michael H. de Young, the publisher of the *San Francisco Chronicle*.

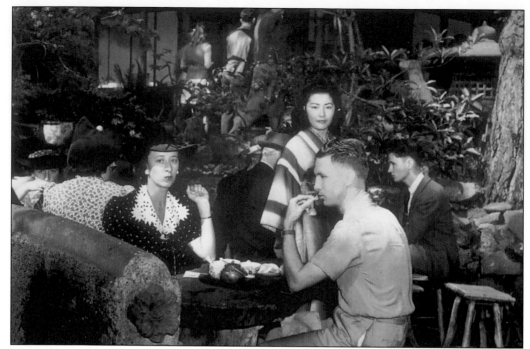

Mr. and Mrs. Clayton N. Opp enjoy afternoon tea and fortune telling cakes at the Japanese Tea Garden as Mary Asano passes by. Mr. Opp, a Los Angeles Coast Guardsman, was on vacation when this September 3, 1941 photo was taken.

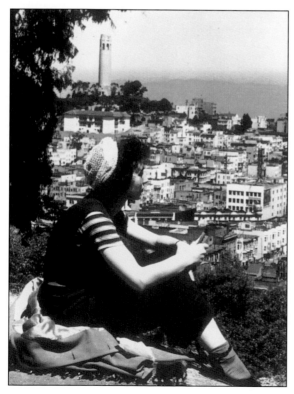

The small park at Taylor and Vallejo Streets on Russian Hill provided Lois Thomas a perfect spot from which to view the city on a beautiful August day in 1944. Coit Tower and Telegraph Hill can be seen in the background.

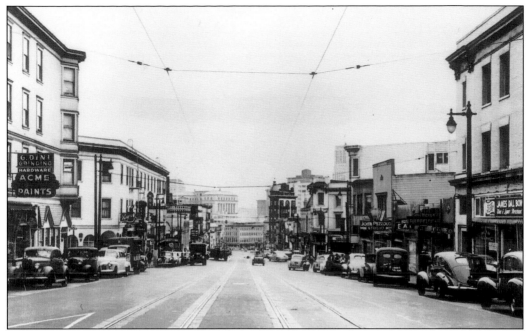

This August 19, 1944, photo shows Columbus Avenue from Vallejo Street looking towards Broadway. This area of North Beach was known as Little Italy, the largest Italian-American business and residential section of the city. Columbus Avenue is named in honor of Christopher Columbus. The building at the very end is Montgomery Block, a prominent business and intellectual center that was demolished in 1959. Today the Transamerica Pyramid occupies the site.

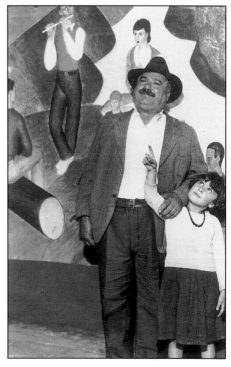

During the depression, the Public Works of Art Project hired 25 artists and 19 assistants to create a series of murals inside Coit Tower. The artists, inspired by renowned Mexican muralist Diego Rivera, created the murals to portray the working life of the City. In this 1934 photograph, Mr. Louis Pasquale and his daughter Merceda view the completed frescoes.

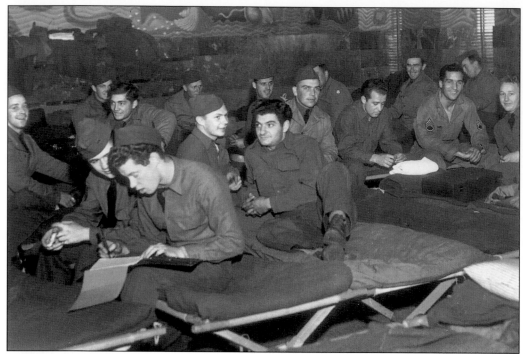

The troops of Battery B, 216th Coast Artillery from Camp Haan used the Aquatic Park casino for barracks while awaiting shipment overseas. At the time, the term "casino" meant bathhouse.

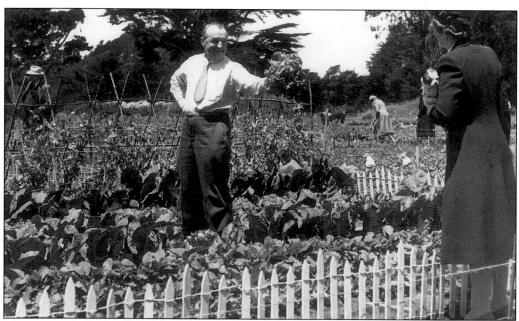

As part of the war effort during World War II, Victory Gardens were common to virtually every community in America. In San Francisco, Golden Gate Park made land available to the public. One of the most abundant gardens was cultivated by Mr. Herbert Simon, who is shown in this photograph.

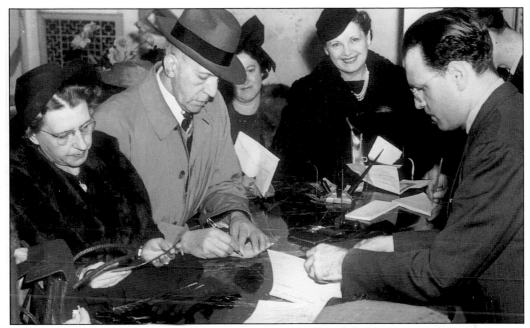

Following Pearl Harbor, patriotic American citizens purchased defense stamps and government bonds to do their part for the war effort. This December 1941 photo shows customers standing in line to buy the bonds at the Wells Fargo Bank at Grant Avenue and Market Street.

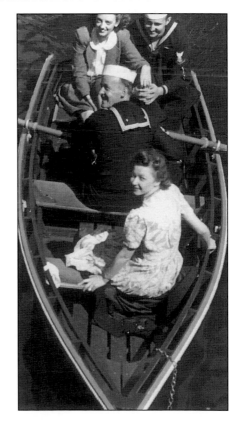

For the men of the U.S. Navy, San Francisco was the last American city they would visit before their ships departed for military action. On June 22, 1943, Edwin and Joan Christie joined Al and Betty Grober for a rowboat cruise. This photo was taken from the small bridge over Stow Lake in Golden Gate Park.

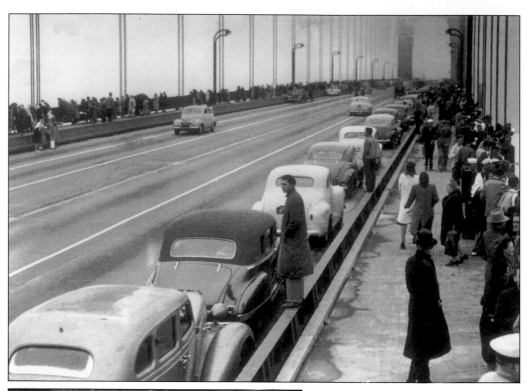

Enthusiastic onlookers gathered on the Golden Gate Bridge on October 15, 1945, to watch the celebrated homecoming of Admiral "Bull" Halsey's victorious fleet. The crowd, shown above welcoming the battleship *South Dakota*, remained on the bridge until the last submarine of the fleet pulled into the San Francisco Bay.

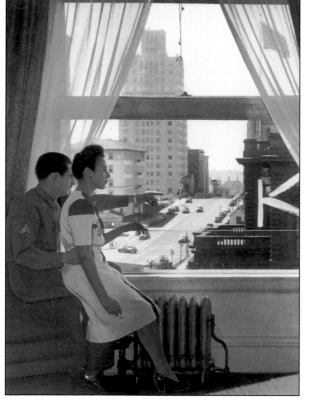

On April 16, 1946, former prisoner of war Corporal Lloyd Griffiths, 28, and his wife Mary were photographed enjoying their view of Nob Hill from their suite at the Fairmont Hotel.

The famous Mark Hopkins Hotel, at the top of Nob Hill, has been a world-class destination for celebrities, statesmen, royalty, and travelers since its opening on December 3, 1926. In 1939, original owner George D. Smith converted the hotel's 11-room penthouse into a glass-enclosed cocktail lounge and the Top of the Mark was born.

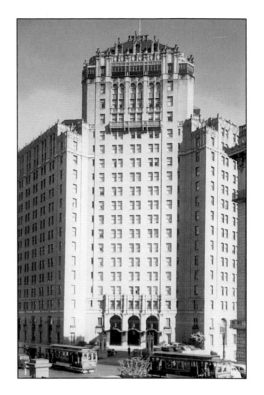

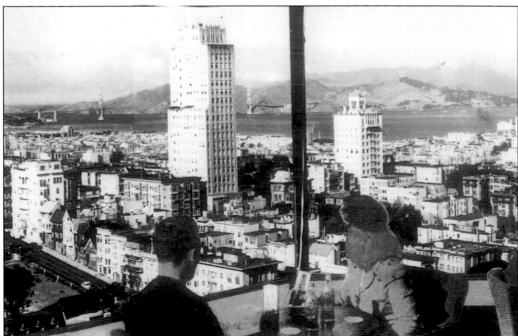

During World War II, lines of servicemen extended into the streets, as they waited to have one last toast at the "Top" before shipping out. The idea was that this toast would bring them home. After the war, many returned with their wives and sweethearts to share with them the dramatic sights they had described in letters.

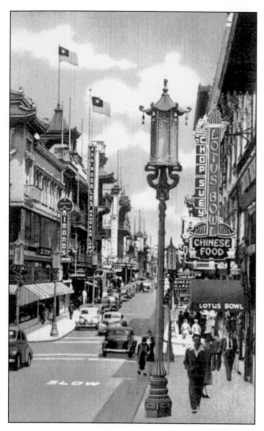

At the time of this 1937 postcard, Grant Avenue was made up almost exclusively of Chinese shops and restaurants. The decorative streetlights were installed in 1925 when Chinatown began its tourist boom. In time, the area of Grant Avenue closest to California Street became dominated by businesses that cater to tourists, who enjoy the colorful architecture and atmosphere of Chinatown, as well as its extensive selection of restaurants, such as the one shown below.

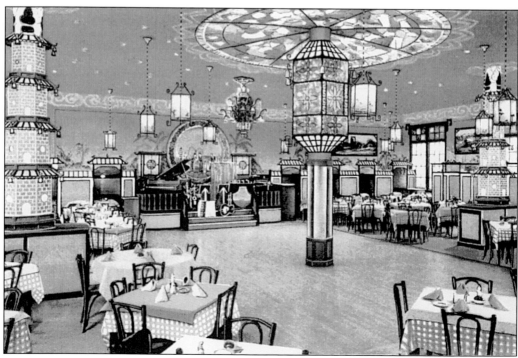

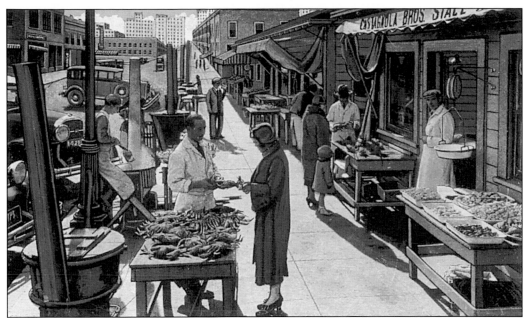

In 1916, Tomaso Castagnola began offering "walkaway" crab cocktails to tourists viewing the fishing fleet. Soon, many Italian fishing families opened stalls selling freshly cooked Dungeness crab from steaming pots along the wharf. In this 1920 postcard, customers are shown the day's selection at the Castagnola Brothers Stall.

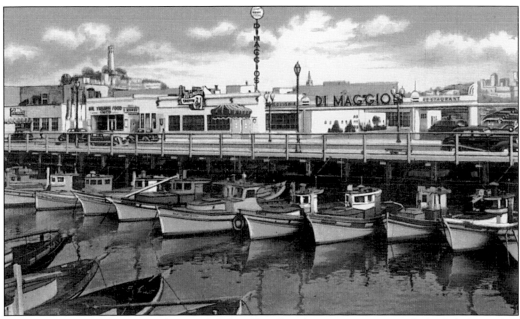

This 1940s postcard shows Fisherman's Wharf lined with restaurants, one of which belonged to the DiMaggio family. The family had three sons who made it to the major leagues—Dominick, Vincent, and of course, the most famous, Joe DiMaggio.

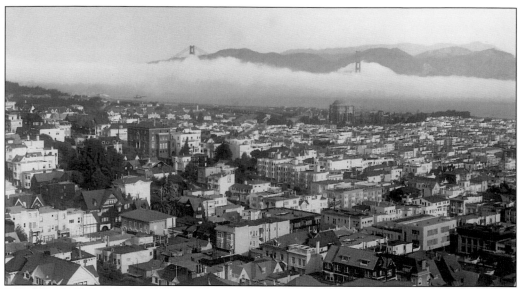

This May 7, 1947 photo of the Marina District, taken from Pacific Avenue and Fillmore Street, shows the cooling San Francisco fog bank enveloping the Golden Gate.

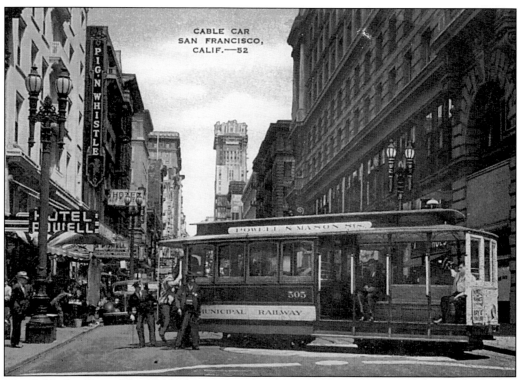

The Cable Car Turntables enable the conductor and gripman to turn the car back in the direction from which it came. In this 1940s postcard, car #505 of the Powell-Mason line is turned at the Powell Street Turntable, at the intersections with Market Street. To this day, waiting passengers, shoppers, business clientele, and tourists alike enjoy watching the cable car tradition.

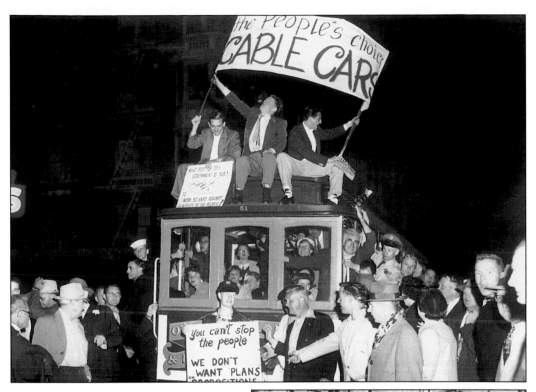

When the city government tried to
replace all the cable cars with buses,
it met with vigorous opposition.
Shown above, a crowd protests the
replacement of the Hyde Street cable
cars during the farewell run of "Old
No. 51." The last remaining car on the
route, she heads for the barn filled with
appreciative passengers.

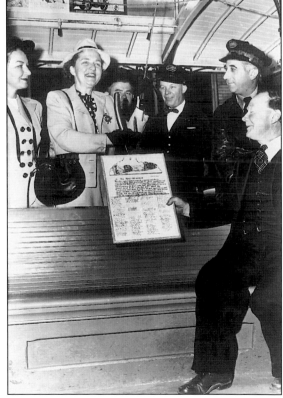

Mrs. Hans Klussman, who in 1947
formed the Committee to Save the
Cable Cars and led the fight to save the
historic treasures, is shown receiving a
letter of appreciation from employees
of the California Street Cable Car
Company. Ernest Thompson and A.J.
Wall (right) make the presentation on
July 28, 1948, on behalf of their fellow
employees, two of whom are looking on,
as is Mrs. Carl Eastman. The successful
fight resulted in three of the original
eight cable car lines remaining in
operation to this day.

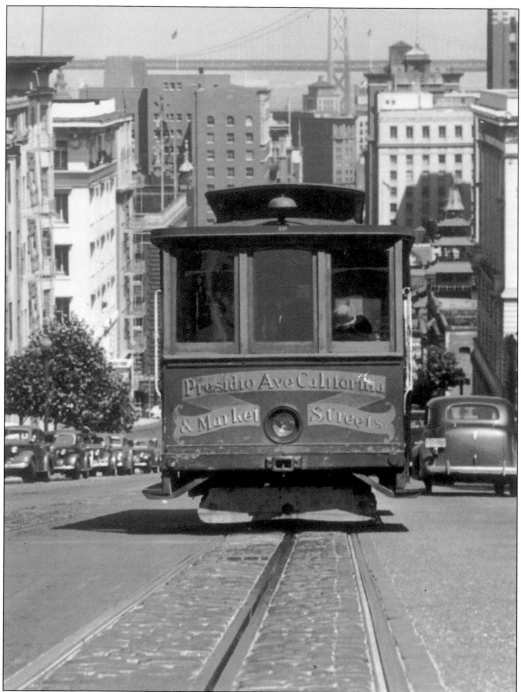

We end our journey through early San Francisco with the quintessential view that holds a special place in the hearts of residents and visitors alike. Looking east on California Street, the 519-foot West Tower of the Bay Bridge looms in the distance. Today, 60 years after this photo was taken, the view remains as breathtaking as ever. The cable cars, which became the nation's first moving historic landmarks in 1964, continue ringing their bells as they climb the hills of a great city into the 21st century.

128